THE ART GUYS : THINK TWICE

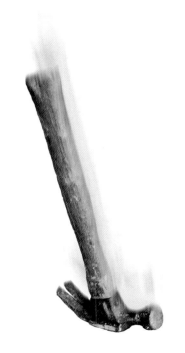

The Art Guys

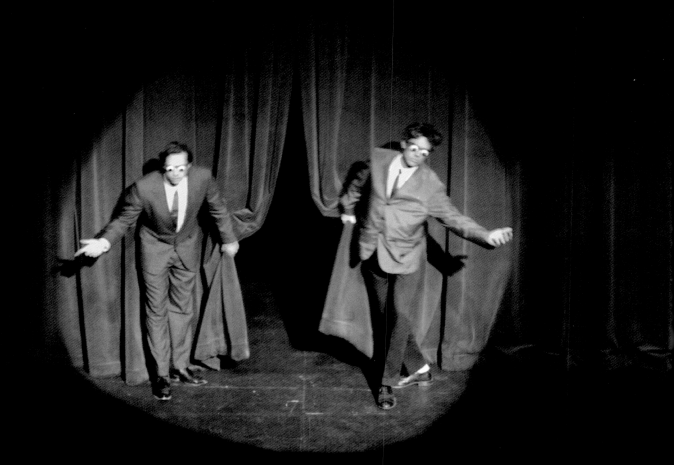

Think Twice

1983–1995

Essays by

Lynn M. Herbert

Dave Hickey

Walter Hopps

David Levi Strauss

CONTEMPORARY ARTS MUSEUM, HOUSTON
in association with
HARRY N. ABRAMS, INC., PUBLISHERS, NEW YORK

This publication accompanies the exhibition:
The Art Guys: Think Twice 1983–1995
April 8 – June 25, 1995
Contemporary Arts Museum, Houston

The exhibition is supported in part by the National
Endowment for the Arts, a Federal agency, Washington, D.C.;
Shell Oil Company Foundation; and the Contemporary
Arts Museum Major Exhibition Fund.

Benefactors:

George and Mary Josephine Hamman Foundation
Mr. and Mrs. I.H. Kempner III

Donors:

Anchorage Foundation of Texas
Arthur Andersen & Co.
Mr. and Mrs. A.L. Ballard
Cooper Industries
Max and Isabell Smith Herzstein
Korn/Ferry International
Windi Phillips
Vivian L. Smith Foundation
Susan Vaughan Foundation
Wilson Industries Inc.

cover and back cover: *The Art Guys Agree on Painting* 1994
(first performed 1983)
Mike and Jack dip their right hands in paint, then shake hands over a sheet of
paper. A painting is produced by this activity (back cover).

page 1: *Excuse Me, I Dropped My Hammer* detail, 1995
hammer, motor, wood, mechanical parts, wire, stanchions, rayon fringe and satin
Mechanized work in which a hammer (hoisted by a cable) is intermittently
dropped, striking the floor.

page 2: *Ta Da* 1995
Heinen Theatre, Houston Community College System, Central College
Jack Massing, *left*, and Michael Galbreth, *right*

Works illustrated in the catalogue are courtesy of the artists and
Barry Whistler Gallery, Dallas, unless otherwise noted.

Library of Congress Catalog Card Number 95–67387
ISBN 0–8109–2654–7

Copyright © 1995 Contemporary Arts Museum, Houston

Published in 1996 by Harry N. Abrams, Incorporated, New York
A Times Mirror Company

Editor: Polly Koch
Design: Don Quaintance, Public Address Design, Houston
 Elizabeth Frizzell, Production Assistant
Typography: Public Address Design; composed in Monotype Dante
 and ITC Franklin Gothic Book and Demi
Color Separations and Printing: Technigrafiks, Inc., Houston
Halftones: Public Address Design, Houston
Binding: Ellis Bindery, Dallas

Photography Credits

All photographs are courtesy the
AGI (Art Guys Inc. Worldwide
Photos) unless otherwise noted.
Art Industrial: fig. 13
Harrod Blank: pl. 61
Bonnie Charles: pls. 20, 163, 166
Ben DeSoto: pls. 18, 19, 164
Randy Ericksen: pls. 47–50
William W. Galbreth: fig. 12
Rick Gardner: fig. 17
Craig Hartley, *The Houston Post*: pl. 1
Paul Hester: *front cover*, page 2, *back
cover*; figs. 6, 8, 27–29; pls. 4, 9, 13,
26, 27, 34, 62–64, 84, 86–90, 105–
106, 109, 117–118, 120, 133, 136,
145, 148, 150, 154, 169–170

Paul Hester & Don Quaintance: pl. 149
George Hixson: page 25
Photographer unknown: fig. 22,
pl. 16
Phyllis Hand Photography: fig. 10
Paul N. Massing: fig. 11, pl. 79
The Museum of Fine Arts,
Houston: pl. 123
Tom Stephens: pl. 91
Sasha Sumner: fig. 20
Barry Whistler Gallery: pl. 98
Casey Williams: pls. 59–60
John A. Wilson: pls. 162, 165
King Chou Wong, *The Houston Post*:
pl. 3

Contents

Lenders to the Exhibition

Arman, New York

Art Guise Ink.

Elizabeth Aston, Houston

The Barrett Collection, Dallas

Toni and Jeffery Beauchamp, Houston

Linda Bednar, Houston

Bill and SueSue Bounds, Atlanta

John and Dede Brough, Arlington, Virginia

David Brown, Houston

Sonny Burt and Bob Butler, Dallas

Michael Caddell and Tracey Conwell, Houston

Russell Duesterhoft, Houston

Patricia A. Galbreth, Nashville

Ian Glennie, Houston

Mr. and Mrs. Michael Goldberg, Dallas

Lynn Goode and Tim Crowley, Houston

Kristie Graham, Tucson

Jesse Gregg and Jill Bedgood, Austin

Trish Herrera, Houston

Carl and Rose Cullivan Hock, Houston

Caroline Huber and Walter Hopps, Houston

Nancy Reddin Kienholz, Hope, Idaho

Tom and Moira Lafaver, Houston

Steve and Pat Lasher, Houston

Marshal and Victoria Lightman, Houston

Carson and Molly Luhrs, Houston

Chris McIntosh, Houston

June and Oliver Mattingly, Dallas

Ken and Andrea Maunz, Kansas City, Missouri

Louy Meacham, Houston

Sarah Shartle Meacham, Portland, Maine

The Menil Collection, Houston

The Museum of Fine Arts, Houston

Private Collections, Houston

Private Collection, Santa Fe

John Roberson, Houston

Rusty and Deedie Rose, Dallas

Marvin and Liz Seline, Houston

Robert F. Smith, Houston

Gary J. Somberg, Houston

Carol Taylor, Dallas

Barry Whistler Gallery, Dallas

Ed and Kathy Wilson, Houston

Foreword and Acknowledgments

The Contemporary Arts Museum is very pleased to present the first major museum exhibition of Houston's collaborative team, the Art Guys. One of the most important roles the Museum plays for the benefit of its audiences is the support and acknowledgment of the city's own art community, both emerging and established. Over the past 15 years, CAM has organized major exhibitions of the work of Texas artists who are well-known outside the region, such as Earl Staley (1983), Joseph Glasco (1986) and Melissa Miller (1986). It has hosted exhibitions of regional artists such as Vernon Fisher (1989) that were organized elsewhere. Additionally, the Museum has organized for its large Upper Gallery several thematic exhibitions that have served to showcase the work of Texas artists. *Four Painters: Jones, Smith, Stack, Utterback* (1981), *Southern Fictions* (1983), the *First Texas Triennial* (1988) and *TEXAS/Between Two Worlds* (1993) have contributed to CAM's role in exhibiting the artists of the region in large-scale exhibitions. Numerous shows of Houston and Texas artists have also been mounted in the *Perspectives* series. Of the 80-some shows included in this long-running series, 27 have focused on area artists in individual or group exhibitions.

The Art Guys: Think Twice 1983–1995 is a 13-year survey of these two artists' work. Jack Massing and Michael Galbreth began working collaboratively as students at the University of Houston. After a very short time, their individual work was subsumed by the intensity and success of their collaboration, and today their identity as artists rests almost entirely in their work under the Art Guys rubric. This is reflected in the exhibition's title—their work represents the thinking process of two artists, and it refers as well to the kind of double take their work forces on the viewer.

In the oeuvre of all mature artists, the entire body of work forms a distinct and indivisible whole expression. For purposes of discussion and clarity, however, the Art Guys' work has been divided in this catalogue into loosely defined categories by Lynn M. Herbert, CAM's Associate Curator and the curator of the exhibition. She sees these categories as useful only when it is assumed that they are fluid and malleable and that many works cross the dividing lines to fit into several of these areas of discussion.

The Contemporary Arts Museum is fortunate to have a committed, active, supportive and visionary Board of Trustees, and the Board's trust in staff expertise, its goodwill toward the art of this region and its active role in procuring needed resources for the Museum's programs result in projects such as the present one. The staff and I are grateful for the support of these extraordinary individuals.

The exhibition has been funded by a grant from the National Endowment for the Arts, a Federal agency, Washington, D.C. Funds are awarded by the N.E.A. as matching funds: every federal dollar must be matched by at least one non-federal dollar. The grant has been matched by support from Shell Oil Company Foundation and by those special and generous individuals, acknowledged on page 4, who contribute to CAM's Major Exhibition Fund. The Fund's donors have ensured the presentation of this show, as well as all exhibitions installed in the Museum's large Upper Gallery, providing Museum audiences with access to the variety of exhibitions that form the backbone of CAM's programs. Russell Duesterhoft, Leslie Elkins, Shannon Sasser and Sharon Chapman, and Treebeards Restaurant have also contributed generously to the project.

The Art Guys make objects but are also well-known for their innovative, unlikely and unusual performance events, and several of these have been planned for the duration of the exhibition. In addition to activities at CAM, the artists will produce and participate in a number of performances elsewhere in the city during the course of the show. The Art Guys, Lynn Herbert and I would like to thank our co-producers and co-hosts of these events: Tana Weiss and The Children's Museum of Houston; Michael Golden and the Houston Community College System, Central College, Art Department; Ginger Renfro and National Convenience Stores; and Joey Kaczmarek and LaBare.

This publication has benefited from the intelligent and insightful contributions of our guest writers—Dave Hickey, Las Vegas itinerant art writer and critic; Walter Hopps, Consulting Curator, The Menil Collection, Houston; and David Levi Strauss, a New York-based poet and critic.

Lynn Herbert would like to thank the following for sharing their time and insights about the Art Guys and their work: Susan Chadwick, art critic, *The Houston Post*; Alison de Lima Greene, Curator of Twentieth-Century Art, The

Museum of Fine Arts, Houston; Houston-based artist Terrell James; Patricia C. Johnson, art critic, *Houston Chronicle*; and Houston-based writer Elizabeth McBride.

In an institution like the Contemporary Arts Museum, major projects such as these require the goodwill and cooperation of many members of the staff. Lynn Herbert would particularly like to acknowledge the contributions of Stephanie Smith, Curatorial Assistant; Susan Schmaeling, Public Relations Officer; Claire Champ, Curator of Education; Tim Barkley, Registrar; Terry Andrews, Head Preparator; Mike Reed, Museum Manager; Christine Farrell, Director of Development; Sue Pruden, Museum Shop Manager; and Lana Sullivan, Receptionist. Mary Katherine Smith, an undergraduate intern from Rice University, assisted with many phases of the exhibition. Lisa McGee, Security Supervisor, and her staff are also to be thanked for transforming themselves into an Art Guys work, *On Guard*, during the presentation of the exhibition.

Lynn Herbert would also like to thank Don Quaintance and Elizabeth Frizzell of Public Address Design who graciously embraced the immensity of this project and have wonderfully captured the spirit of the Art Guys with this publication. Polly Koch offered careful and exacting editorial expertise. Paul Hester was instrumental in photographing many of the challenging works in this catalogue, including the cover image. Bill Howze of Documentary Arts has brought his considerable skill and knowledge to the production of the video program that accompanies the exhibition.

In the end, any exhibition at the CAM, a non-collecting institution, comes from idea to reality only because of the generosity of the lenders who agree to live without their works of art for a time so that larger audiences may benefit. We are very grateful to the many lenders to *The Art Guys: Think Twice* who are listed on page 6.

I have been fortunate to be a small part of this project that was originally conceived by Lynn Herbert under the tenure of my predecessor, Suzanne Delehanty. I am grateful to Lynn Herbert who has carried forward the project with great skill, sensitivity and knowledge. Her considerable abilities have truly been tested in dealing with the nontraditional, ephemeral and unconventional nature of the Art Guys' prodigious output over the last 13 years. To be the second art historian to bring a critical eye to bear on contemporary work is often an enviable position. To be the first, as Herbert has been in this case, is challenging and maddening, but it is of great service to the public, to contemporary art history and to the artists under consideration. Lynn Herbert has been the pioneer in this case, and she has shown the way for the rest of us.

Lastly, the curator and I wish to thank the artists for their time, their patience and their many, many contributions to this project. Both have given unstintingly of their knowledge and their energy to ensure the exhibition's success.

Marti Mayo
Director

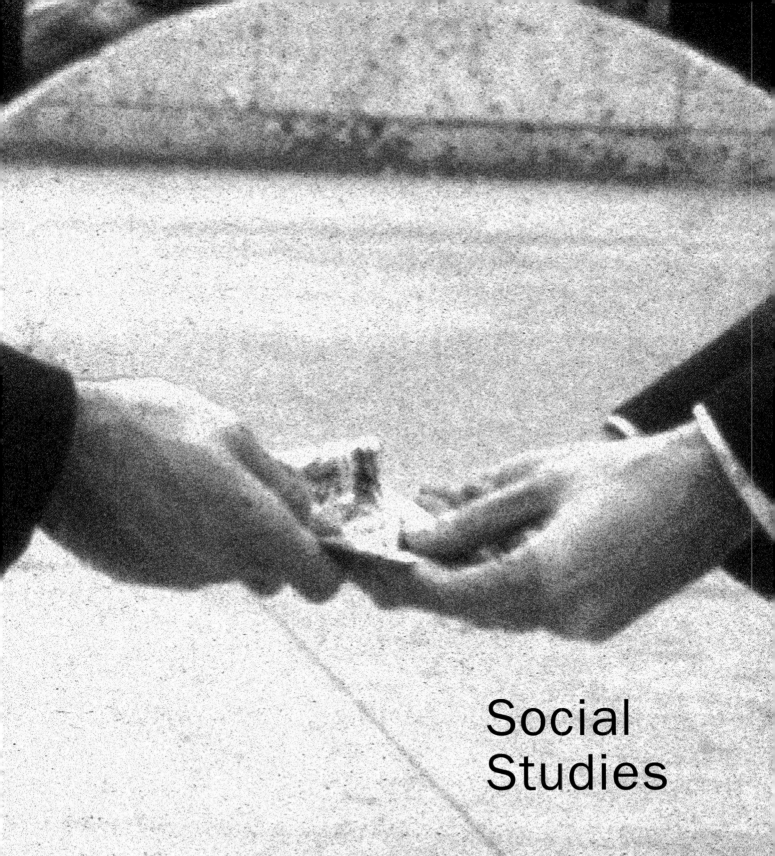

Social
Studies

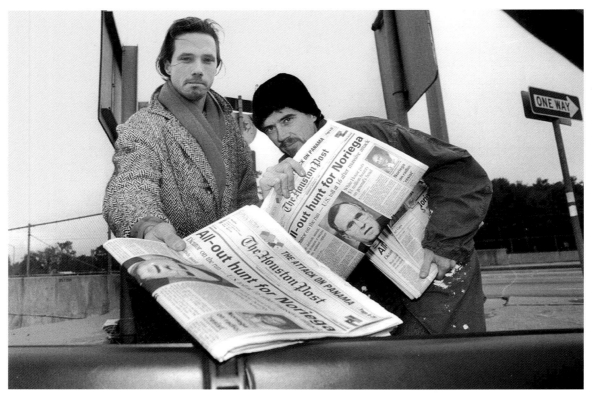

1. **December Distribution Doubletake** 1989
Interstate 10 at Washington Avenue exit
Selling newspapers on a street corner from sunrise to sunset.

previous page: **Blue Sunday** detail, 1984 *(see pls. 10–12)*

opposite:
4. **Art Guys Business Cards** 1986–present
Business cards designed to accompany a
variety of activities.

2. **Yard Crew** 1990
Contemporary Arts Museum, Houston
Lowering the lawn in "an even manner."

3. **Dining at Denny's: Food for Thought** 1988
Denny's Restaurant, Interstate 10 at Washington Avenue exit, Houston
Spending 24 hours in a booth at an all-night restaurant.

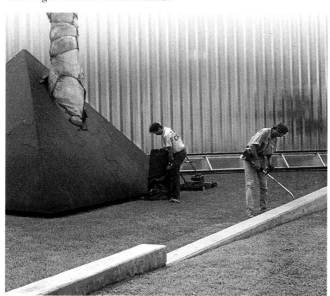

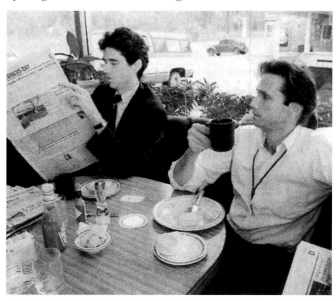

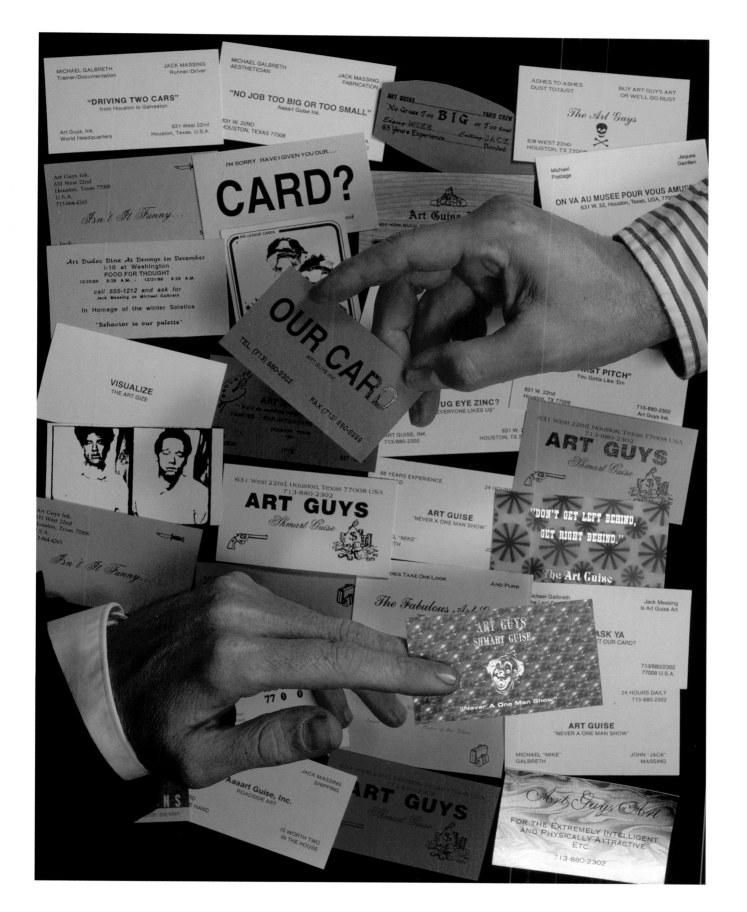

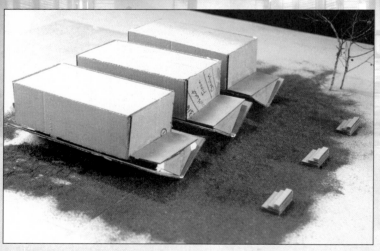

above:
5. Phantom Neighborhood
detail, 1990
Buffalo Bayou Park, Houston
25 abandoned concrete steps
from Fourth Ward row houses
relocated to the banks of
Buffalo Bayou as an alternate
installation to rejected proposal
(right).

background:
6. Row houses, Fourth Ward,
Houston

left:
**7. "As we build our city let us
think that we are building forever"**
maquette, 1990 (project not realized)
Buffalo Bayou Park, Houston
cardboard, tape and model maker's
grass

For the 1990 *Landscapes* exhibition
the Art Guys proposed installing,
upside down, three abandoned
shotgun houses from the adjacent
Fourth Ward neighborhood. The
City Parks Department rejected
the plan and the Art Guys instead
presented *Phantom Neighborhood*
(above).

8. **Bonded Activity #19** 1991
(see pl. 153)
pencils and glue
Collection John and Dede Brough,
Arlington, Virginia

9. **Goatee Off: Manifest Destiny** detail, 1991
U.S. postage stamps on paper
Collection Louy Meacham, Houston

Buffalo Bills' goatees cut out and affixed to Red Clouds' chins.

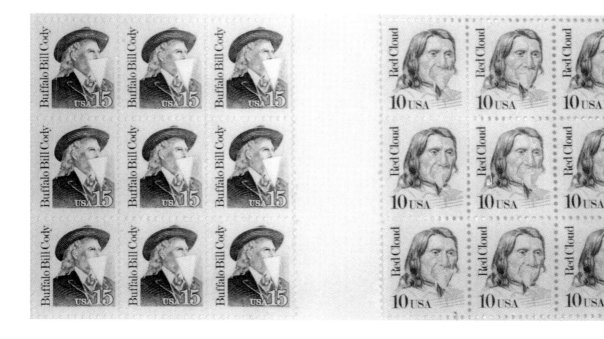

10–12. **Blue Sunday** 1984
steps of City Hall, Houston
Selling goods (including bed sheets, nails and boots)
banned by blue laws from sale on Sunday.

13. **First Pitch** 1990
The Astrodome, Houston
Image from videotape of throwing out the first pitch
at a Houston Astros vs. New York Mets baseball game.

"Well, Tom and Joe are businesspersons. They run a mom-and-pop shop, Strange & Tilli, Inc. Only it happens to be embedded in a company called Titeflex, which itself is embedded in a company called the TI Group. But make no mistake—this is Tom and Joe's little corner of the world, their enterprise. They routinely deal with insiders and outsiders of all kinds, and there is no intervention from management. They take whatever initiative the business requires, which is usually a lot.

What kind of workers are Strange & Tilli? It's a trick question. Consider again the animating theme running through this book: 'more intellect, less materials,' 'the only factory asset is the human imagination.' Tom and Joe are knowledge workers. They aren't just selling hose. Far from it. They are selling relationship management, customization and responsiveness. They are selling, in a word, brainware. A lump (hose) is involved, just as it is at 3M in Austin, but the value added (and most of the sticker price) is the knowledge they incorporate into the hose and the service they wrap around it."

Tom Peters, *The Tom Peters Seminar: Crazy Times Call for Crazy Organizations*

Laughter Takes the Bus

DAVE HICKEY

Okay, I'm going to talk turkey here: the Art Guys are sort of a problem. Which is to say, everybody likes the Art Guys but only sort of. I mean, people *say* they like the Art Guys, but there is always this little hitch in their voice, this frisson of reservation. Because something is not quite *right* about the Art Guys and what they do. Their work is smart enough, of course, reasonably priced and often very fetching to look at, but somehow these guys are not *quite* giving the art consumer what he or she requires. The "steak" looks all right, but there is an acrid tang to the "sizzle"—an alien edge that might be construed as being, well . . . how can I put this . . . a little *contemptuous*? So, art people, having said they like the Art Guys (sort of), qualify their commitment by saying, "Well, I 'love' what they do," with "love" in scare quotes—as one might say one "loves" Las Vegas, or Roseanne Barr, or Dr. Kevorkian, or anything sort of exciting but not quite right, you know.

So, people like the Art Guys, sort of, and "love" what they do in scare quotes. Which, I think, is simply to say that people enjoy the product but feel the lack of something *out there* to attach it to, some abject persona or progressive social idea—because, even though it's been 25 years since Roland Barthes killed off the "author" (Nietzsche having done the same for God somewhat earlier), we still seem to long for that cuddly little touch of the personal to make our art experience right: to make it more like "giving" and less like "taking." Failing that, we require art with the patina of disinterested, institutional solemnity that will ennoble our ennui with the brown haze of pedagogy—to make our experience less selfish and more saintly. And the Art Guys (whose names are genuinely unimportant here, who deserve their privacy) don't give us anything on either score.

They may have it, but they will not give it up. Because they are the Art Guys and they do retail! They traffic in "guises" and do business by doing "guy" things. They snitch stuff from people's houses. They sit around in Denny's for days at a time. They peddle newspapers on freeway off-ramps. They imagine quixotic technological innovations. They obsessively assemble zillions of tiny things to make great big things, apparently aspiring to do for "guy stuff" what Warhol did for "gay stuff"—by practicing, as Andy did, identity politics as farce: by reconstituting contempt and anger in the guise of shrewd marketing (figs. 1 & 2). Which is only a guise, of course, because, by art world standards, the Art Guys do *terrible* marketing. I mean, let's face it, the Art Guys' marketing *looks like* marketing, while art world marketing, at its best, looks like public service, like the generous opportunity to redeem the bitter fruits of capitalism.

Successful art world marketing (as opposed to Art Guys marketing) appeals to the art consumer's care, generosity, refinement, intellect and sense of community service. Thus, as any art dealer will tell you, in the area of marketable art, pain and virtue ride the limo. Laughter takes the bus. The contemporary art consumer buys attenuated angst, academic rigor, anomie, petulance, false intellect, false modesty and that ambience of "elevated depth" that Karl Popper found so risible in Frankfurt School philosophy. As a consequence, art world marketing cannot, *must not*, appeal to the consumer's desire. It cannot purport to fulfill his or her "needs." It cannot imply, in any way, that the consumer *lacks* anything, because the art world consumer is, by definition, beyond desire, lacks nothing, needs no nourishment and therefore may dwell in the hallowed realm of "taste."

For many years, of course, this idiom of discernment, this rhetoric of "taste," expressed itself as a decadent European taste for "objects of virtue." Today, however, it is formed around a Puritanical American taste for "virtue itself"—for pure, embattled goodness. The febrile aura of elite discrimination remains intact, however, and redolent with noblesse oblige. By comparison, the Art Guys' marketing smells like teen spirit—and, considered in terms of the job at hand, it is *totally* lame. Delight us as it may, it does not flatter or empower us. Quite the reverse. It reminds us that we are not complete. It implies that we live in a condition of lack, that we flounder in a limbo of desire, all of us, regardless of age, race, gender or sexual persuasion.

So the Art Guys repudiate our pretensions to "taste" with sculptures made of food—oranges, potato chips, Tang, et al. They giggle at our pretentious ascription of therapeutic virtue to works of art by proffering elaborate minimalist sculptures assembled from spansules of over-the-counter medicines. And then, adding insult to injury, they remind us of just how far we are from having it all by demonstrating that even what we *had*, just a moment ago, has been stolen from us: little things—like laughter, volition and happy anxiety—and other things we didn't even know were gone until the Art Guys proposed to sell them back to us, nicely tarted up in glass vitrines.

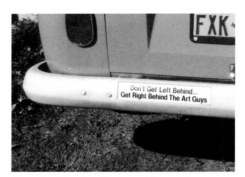

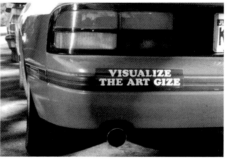

figs. 1 & 2 Art Guys bumper stickers, 1991–present, silkscreen on vinyl

As Michel Foucault has astutely pointed out, the great task of twentieth-century culture has been to make us feel good about feeling bad. The Art Guys turn the tables on this Puritan masochism and in so doing make us feel uneasy about feeling good. They taunt our pretensions with inno-

cent fun and indict us with amusement. Which is why people used to "worry" about the Art Guys all the time and why this "worry" quickly turned to annoyance when the Art Guys didn't change and didn't go away. The fact that they did neither, I think, gives us the right to ask just what the Art Guys might be *selling* with their particular brand of kamikaze commerce?

I would suggest that they are marketing marketing itself. I see no other option. Nor can I imagine a more transgressive agenda to pursue within the unctuous, hierarchical confines of American high culture at the end of the twentieth century. In a setting like this, one could *only* embrace trade on behalf of trade itself—on behalf of the democracy of it—in aid of the horizontal, protean relationships that it engenders and perpetually recreates. And this, I think, is what makes the art of the Art Guys "art" in the critical sense, since by marketing marketing (as Warhol advertised advertising) the Art Guys assault the bonding agent that holds "high culture" together at this point in history, since heiresses and academics, mandarins and Marxists, all concur in their disdain for trade. All fear "the retail life" in which two parties exist in a condition of reciprocal desire and equity, each wanting what the other has and each willing to trade for it. This reciprocity makes possible not only commerce but the commerce in ideas that was once the jewel of this civilization. So this is where the Art Guys stand, two guys in a wide space once occupied by Gutenberg, Raphael, Voltaire and Dickens—a place where commerce, evangelism and the confirmation of senses may coexist—where we may *see* what we lack and, finding it not the worst thing to want, strive to attain it.

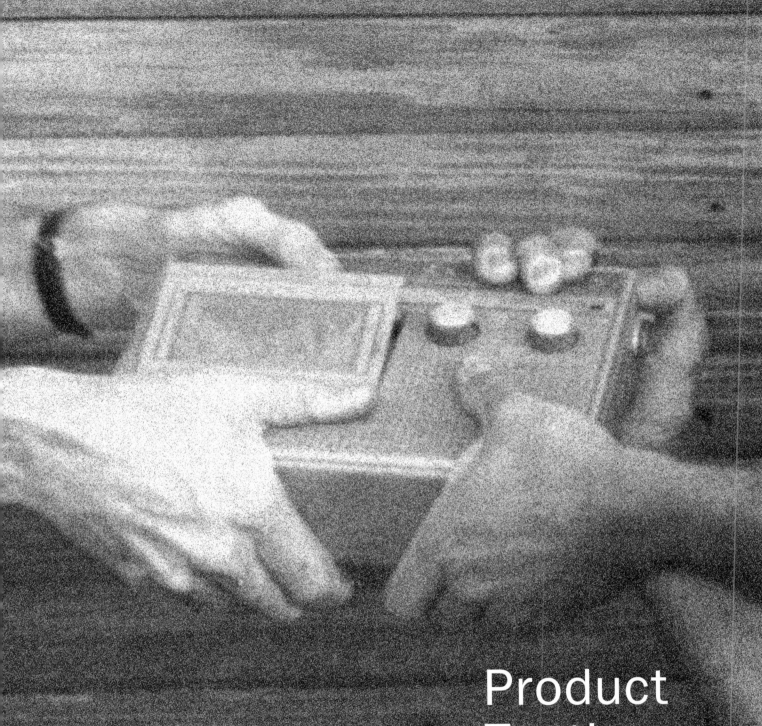

Product
Testing

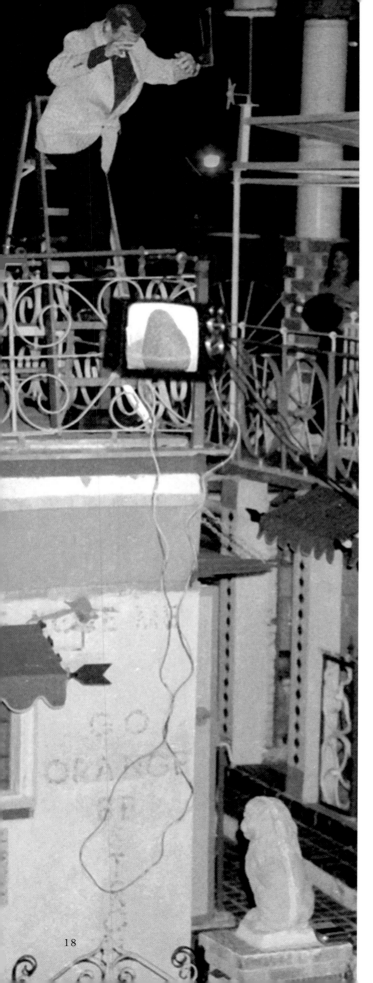

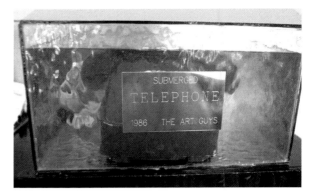

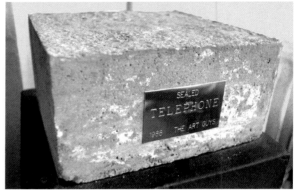

14. **Submerged Telephone** 1986
functioning telephone, glass, silicone, water and brass plaque

15. **Sealed Telephone** 1986
functioning telephone, concrete, silicone and brass plaque

previous page: **Two Grown Men Can't Pull It Apart** detail, 1989
(see pls. 37–45)

left:
16. **Rock Drop: The Video** 1988
The Orange Show, Houston
Stunt man John "Red" Trower dropping a video monitor displaying
a rock at *Stunt Nite,* an evening of performance organized by
the Art Guys.

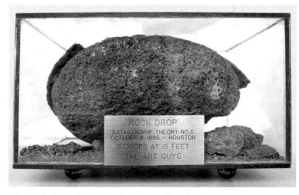

17. **Rock Drop: Catastrophe Theory No. 6** 1985
rock, marbles, silicone, glass and brass plaque
Private Collection, Santa Fe

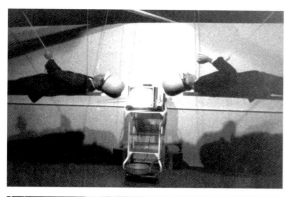

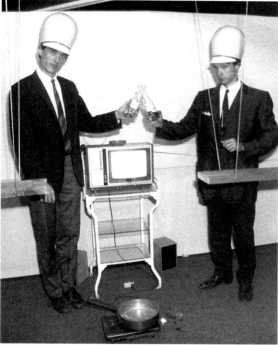

18–19. **Breakfast of Champions** 1987
Frank Carrell's loft, Houston
The Art Guys field sports questions from the audience, then lie
down on suspended boards wearing drum major hats. As their
heads collide, they crack a suspended egg that falls into a frying pan.
A television plays the Home Shopping Network and a soundtrack
repeats the name "Kiki Vandeweghe" (a former NBA basketball player).

20. **Drop Stuff on Mike's Head** 1993 (first performed 1990)
Marshall University, Huntington, West Virginia
Jack dropping a variety of objects and materials on Mike's head.

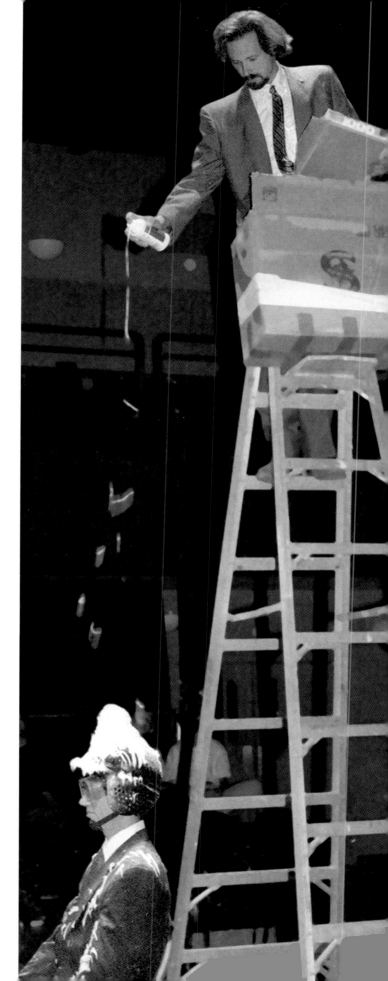

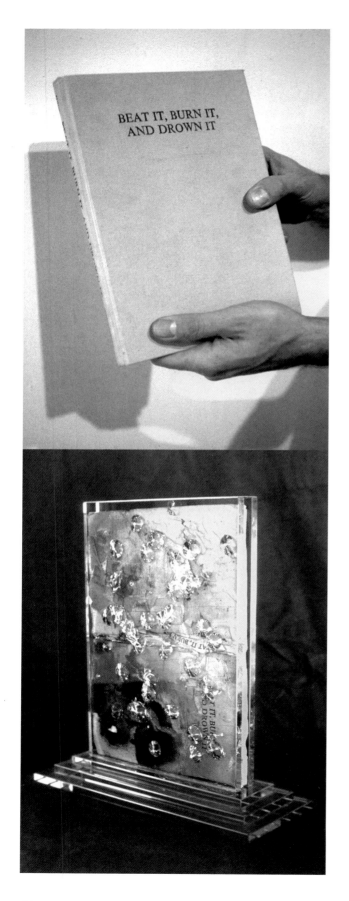

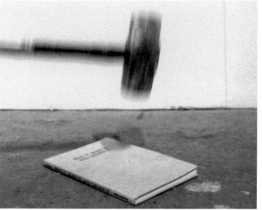

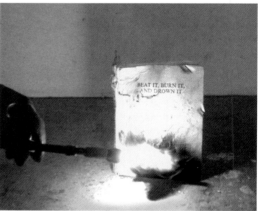

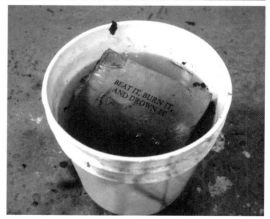

21–25. **Beat It, Burn It, and Drown It** 1987
book, glass case and brass plaque
Collection David Brown, Houston

A book on product testing was subjected to the operations described in its title. *Clockwise from top left:* original book, operations and finished product.

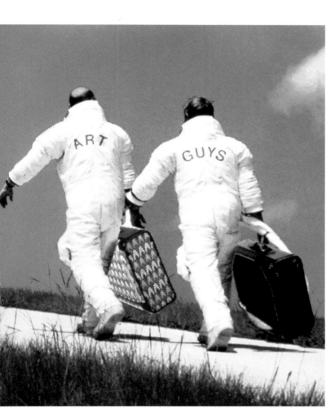

26. **On the Way to the Launch Pad**
from **Suitcase in Space Project** 1988
magazine cutouts, dry transfer lettering and glue on paper

27. **Suitcase in Space**
from **Suitcase in Space Project** 1988
suitcase, gold foil, ceramic tile, globe,
monofilament and brass plaque

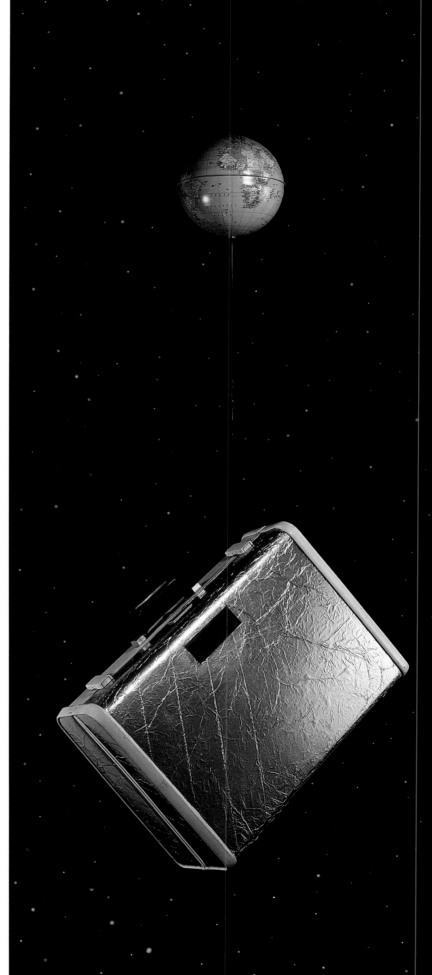

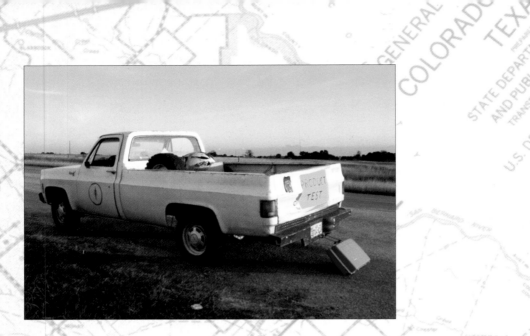

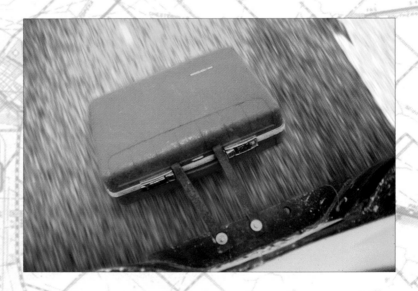

28–31. **Product Test #1: Suitcase Drag, Houston to San Antonio, Highway 90A, 234.7 Miles** 1987
suitcase, Type C print and brass plaque
top to bottom: suitcase attached to truck bumper; in transit; and installed as finished product (at Blue Star Art Space, San Antonio); *background:* map of route.

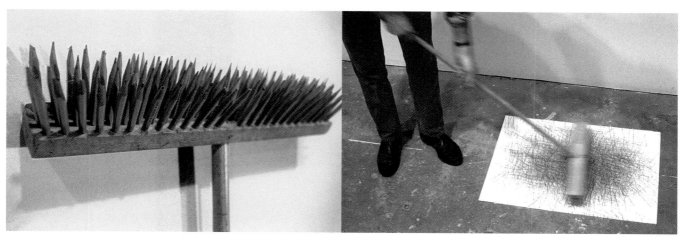

32. **Pencil Broom** 1988
wooden broom and pencils
Collection Alex de Leon, San Antonio

33. **Pencil Broom Drawing** 1988
graphite on paper
Collection Alex de Leon, San Antonio
One from series of 10 (photo shows work in progress).

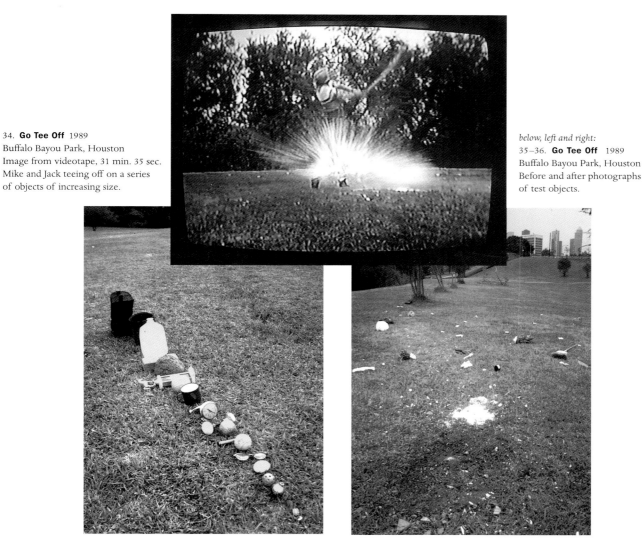

34. **Go Tee Off** 1989
Buffalo Bayou Park, Houston
Image from videotape, 31 min. 35 sec.
Mike and Jack teeing off on a series
of objects of increasing size.

below, left and right:
35–36. **Go Tee Off** 1989
Buffalo Bayou Park, Houston
Before and after photographs
of test objects.

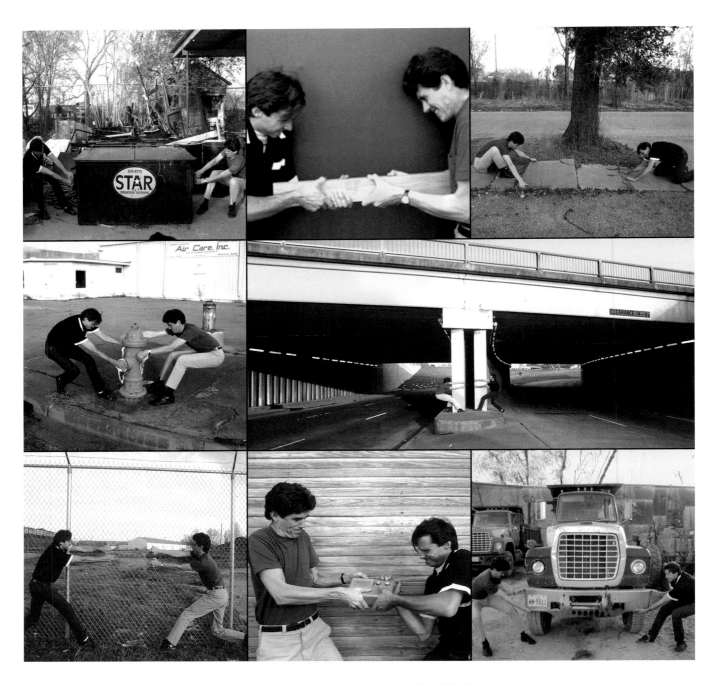

37–45. **Two Grown Men Can't Pull It Apart** 1989
various locations, Houston
A newspaper advertisement *(right)* inspires
attempts to pull apart a variety of objects and
structures.

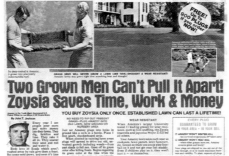

Human
Condition

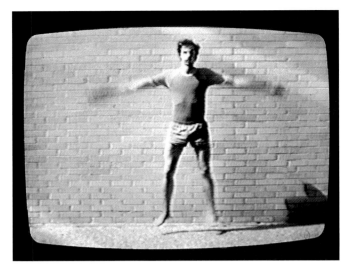

46. **Jumping Jack** 1983
Fine Arts Building, University of Houston
Image from video, 2 min. 15 sec., in which abruptly edited frames
of Jack jumping create an artificially contrived movement.

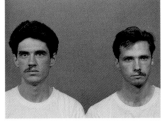
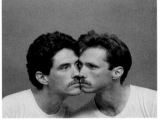
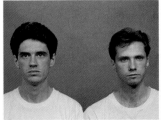

47–50. **Smushing Our Faces Together to Make One Mustache
from Two Half-Mustaches** from the **Mustaches for Seattle Project** 1986
911 Contemporary Arts Center, Seattle, Washington
silver gelatin prints

previous page: **Art Guys Press Photo #397** detail, 1992
silver gelatin print

51–52. **Slap Happy** 1989 (first performance)
DiverseWorks, Houston
Jack slaps Mike periodically until Mike can't take it any longer.
At some performances, roles are reversed.

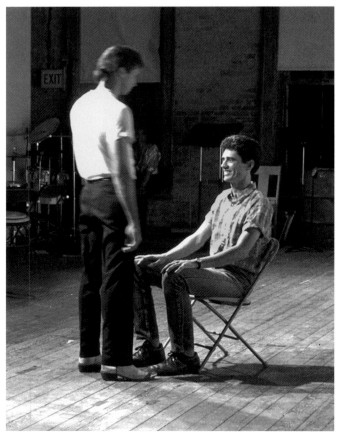
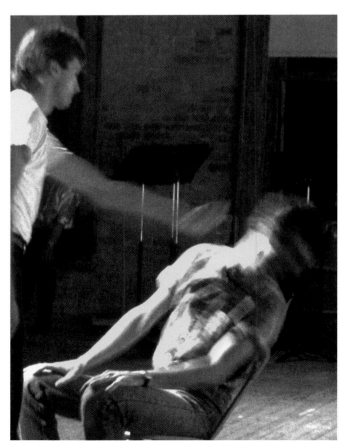

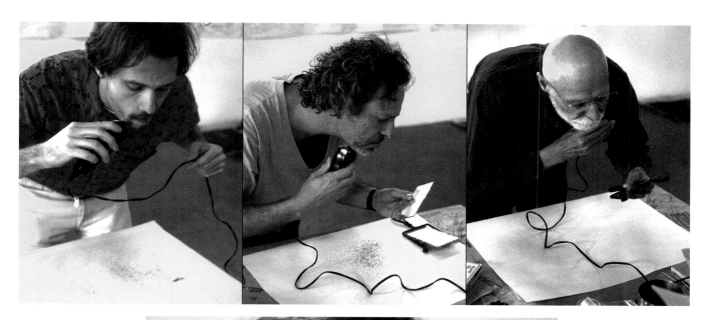

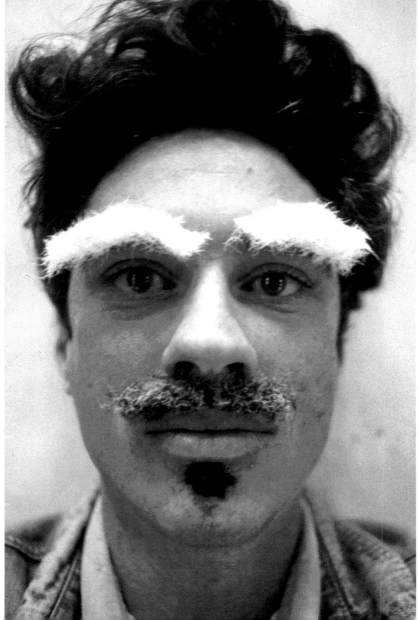

53–56. **The Three Stages of Man**
1992
Art Guys studio
Jack Massing (age 34),
Donald Lipski (age 50) and
Robert Delford Brown (age 65)
shaving off facial hair.
Trimmings reassembled on
Michael Galbreth's face in
chronological order.

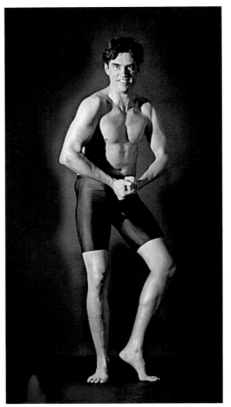
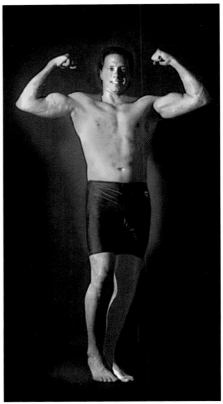

57–60. Bulk Up for CAM 1994–95
silver gelatin prints
Before and after photographs of a 12-month
body conditioning project preparing for survey
exhibition at the Contemporary Arts Museum,
culminating in an unveiling performance at
LaBare, a ladies' club in Houston.

61. Bucket Feet 1994
downtown Houston
Walking ten miles wearing galvanized tubs
filled with water, which were periodically
replenished.

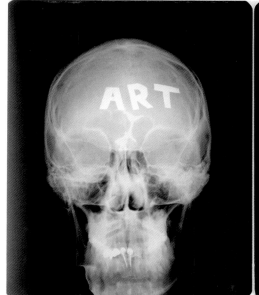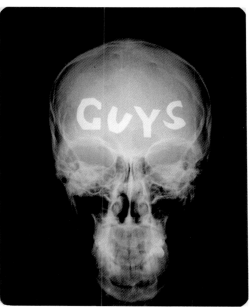

62. **Art Guys X-rays** 1990
x-rays and lead tape
A collaboration with Simon Kahn for
*See Through Us: A Survey of Portraiture
under the Guise of Art*—an exhibition
of portraits of the Art Guys created
by 95 artists (presented at Treebeards
Restaurant, Houston).

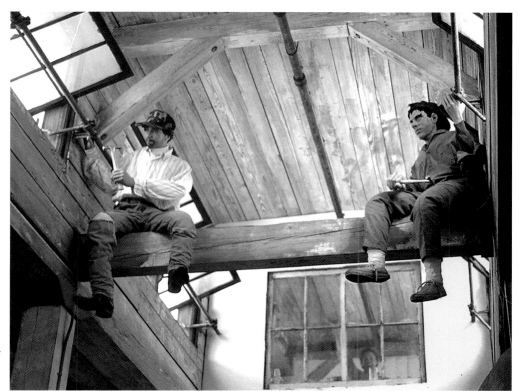

63. **Working Art Guys** 1995
Art Guys Studio
chicken wire, expanding foam sealant,
paint, clothes, tools, motor, wood
and wire
Life size mechanized figures.

64. **Art Guys Action Figures** 1995
plastic, plumber's putty, wood, glue, straight pins and paint;
wooden platforms and glass domes *(not shown)*
5-inch figurines of the Art Guys fabricated by Joe W. Porter,
MasterCon Gold Medalist model maker.

Pick up your skirts, ladies and gentlemen, we're going for a ride on the Art Guys. There will be thrills and spills galore, no doubt, and uplifting educational experiences at nearly every turn. There will be laughter and tears and not a little confusion, and when it's all over you may want to check your valuables.

Why, you ask, would two young men of promising warp and woof leave their altogether adequate surroundings in Buffalo and Nashville to strike out for Space City? And once in the once-oily city, why were these two innocents drawn mysteriously to the mythical Lawndale[2] and thrown together into a bonding of such perspicacity and propitiousness that people in the know would later say they were born to become . . . The Art Guys? These are things we cannot know. But let this not keep us from surmising.

> And now, said Mercier, the time is
> come for us.
> For us? said Camier.
> Precisely, said Mercier, for us, for
> serious matters.
> What about a bite to eat? said Camier.
> Thought first, said Mercier, then
> sustenance.[3]

To glimpse the real origins of the Art Guys Phenomenon, we must begin in ancient Greece, at that point when the Dionysian phallic rituals began to turn into comedic entertainment. To the attendants of Dionysus, the ithyphallic satyrs, fell the comedic burden, and lo, they were up for it. The phallus, it should be remembered, began as a mere stick—a young olive shoot usually—carried in solemn procession in Dionysian festivals. This solemn stick would eventually be transformed into the Fool's scepter or bauble.[4] From it grew the medieval follies, from the Latin *follis,* meaning "windbag" or scrotum (always being tied to tumescent masculinity) and eventually gaining the sense of actions overblown and bombastic. The master of folly was the Fool, who enjoyed nearly full employment during the Middle Ages, thanks primarily to the Church: the Fool's cap, with ass ears and bells, was originally conceived as a mockery of the monk's cowl. Blasphemy then carried a charge that has been almost entirely lost today. Also unlike today, the pious in the Middle Ages recognized their need for Fools. The Vatican was a major employer. Fools told ob-

Hey, Don't Laugh

Stultorum Infinitus Est Numerus:[1]

The Art Guys in the History of the World

DAVID LEVI STRAUSS

scene jokes, parodied powerful men and nations, performed acrobatic feats, made fun of their employers and mixed freely with poets and philosophers. This was a time when "silly" still meant "blessed." The Fool operated on the borderline between good and evil, order and chaos, reality and illusion, truth and falsity, existence and nothingness. Then, as now, comedy was very serious business indeed. You can die out there.

The Fool's edginess remained alive throughout Christendom in the guise of Gargantua, Pulcinella, Robin Goodfellow, Pierrot, Harlequin, Tyl Eulenspiegel, Prince Mishkin, Mercurius, Parsifal, Rigoletto and the Devil,[5] among others, until the Fool became more domesticated and the court jester turned into the circus clown. One often finds the Fool in pairs, from Shem and Shaun and Tweedledum and Tweedledee to Laurel and Hardy (whom the Germans call Dick & Doff), Harpo and Groucho, Mercier and Camier, The Kipper Kids, Gilbert and George, Fischli and Weiss, Beavis and Butthead and Mike and Jack (known in the world outside their home as the Art Guys).

The term "guy" is Teutonic in origin, meaning to mock or make fun of, but it is also related to "guide" and "guise" (cognate with "wise," allied to "wit"), referring to the way something seems to be—its outside appearance. In the theater, one "guys" something when one makes it an object of ridicule by innuendo or derisive wit. The British have used "guy" to refer to one who is odd or grotesque in appearance or dress. Of course, they also insist that the original "guy" was Guy Fawkes, who they say was involved in a fifteenth-century attempt to assassinate the King and blow up the entire Parliament, but frankly, who cares?

Now please direct your attention to figures 3 and 4. Here we have two very early portraits of the Art Guys. Jack is on the left (fig. 3), with a lynx going after his balls, and Mike is on the right, in feathers and neck-scrotum (fig. 4). In Jack's portrait, as so often in life, the little head is telling the big head what to do, a condition many believe defines the male of the species. Figure 5 is a more recent, more idealized, composite portrait. With the sun at his back, the archetypal Art Guy strolls obliviously toward a precipice. The little white dog (representing the art critic) tries to warn him by yapping

incessantly but is ignored as usual. The dog might also be trying to tell the Fool that the bag he carries on his stick actually contains the magical implements that would allow him to do whatever he wants, if he would only realize they were there.

> You hinder me more than you help me, said Mercier.
> I'm not trying to help you, said Camier, I'm trying to help myself.
> Then all is well, said Mercier.[6]

Fools and foolery are rife and rampant throughout the history of art, of course, since art is no more foolproof than are religion and science. In recent history, Marcel Duchamp, Andy Warhol, and Joseph Beuys have all represented different types of high foolery. And the tradition has been extended, or at least repeated, by artists as disparate as Vito Acconci, Richard Prince, Jeff Koons, Sigmar Polke, Karen Finley, Guillermo Gómez-Peña, James Lee Byars and Jimmie Durham, to name a few.

The Art Guys have been most directly influenced by Fluxus.[7] Like Fluxus artists, they go toward the expressive side of conceptualism, use cheap, everyday materials and stage theatrical events that stress the communal and democratic. They also share the Fluxus lust for the encyclopedic and its love of crummy gags and jokes. As Fluxus historian and curator Jon Hendricks has written, "Fluxus makes ideas reachable through gags. You can get it quickly, directly, without beating around the bush. It is what it says it is."[8]

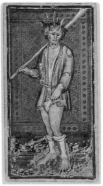

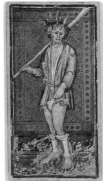

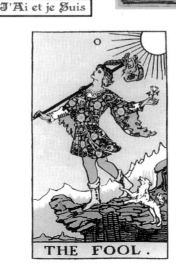

figs. 3–5 *le Fou, J'Ai et je suis* tarot card from *L'Arbre du Thot;* Fool from *Le Tarots des Visconti;* The Fool from the *Rider Tarot Deck*

Unlike most Fluxus artists, the Art Guys have always identified themselves with the average guy and played shamelessly to the crowd. They are among the least alienated artists working today. Joe Sixpack loves their bottle sculptures. Aunt Gerty appreciates their pill constructions. They make art from common household items. They play golf (sort of) (pls. 34–36). They whittle, ferchrissakes (pls. 123–124)! And most of what they do is as accessible as

the evening news. In fact, it often *is* the evening news.

Certain Art Guys actions are designed to slide painlessly into the "non-art human interest" media format. The local Eyewitness News coverage of the Guys spending 24 hours eating and drinking at Denny's to mark the winter solstice (pl. 3) opened with this lead: "To the untrained observer, these guys are just sitting around at Denny's passing the time. But Jack Massing and Michael Galbreth are doing much more than that. They are creating a work of art." The hook is always "Here are some of those wacky artists doing crazy things and calling it art," and the conceit is "They think it's art, but we know it's not; I mean, my six-year-old son could . . . ," etc. Thank you, Morley Safer.[9] The Art Guys are on it but not of it. When the reporter asked Mike what it all meant, he said, "This is definitely *dining,* and that was our intent," and Jack said, "This isn't a performance; this is *behavior."* Then the producers cut back to the anchors in the studio, who expressed their Everyman befuddlement in the face of modern art. The female anchor kidded the male anchor about how he'll need to hurry on down there to see it before it's over, and the male anchor said it reminded him of an off-Broadway play years ago that consisted of a family live on stage. "That was it," he said in amazement. "They were just there, living, and you went and watched them. It was the only play I could get tickets to." Ba-*boom.*

If, as, Jean Cocteau said, "Art is the rehabilitation of the commonplace," then the Art Guys are halfway there. And if, as Francis Picabia said, "Art is a drugstore product for imbeciles," well, the Art Guys are wholesale pharmacists on a mission. As sculptors, their stated approach to materials is "anything is fair game." But this is not to say they choose their materials haphazardly. In fact, each item used must meet certain strict criteria. It must be (a) common, consumer grade, easy to find and cheap; (b) either degraded, recently obsolete or generally devalued; and (c) detachable in form and content. The objects and materials they use are not really

abject. They're more common than that: matches, pennies, beer bottles, nonprescription drugs, food items (carrots, Pringles, Tang, Total), toothbrushes, birdhouses, cigarettes. These things are so ubiquitous that they have become invisible. They are beneath notice.

When the Art Guys use paint, it is common house paint, usually in discarded (bad mix) colors. Even in this degraded form, the paint is intended as a synecdoche for art. In their famous handshake, *The Art Guys Agree on Painting* (1983, cover and back cover), known to art historians as the Lawndale Oath, rejected-mix orange and green paint flows together as the Art Guys agree to "cover the world." And in *1,000 Coats of Paint* (1990–91, pls. 132–138) they fulfill their telic oath by using paint in a faux-meticulous, painstakingly workmanlike way to cover selected objects—telephone, teddy bear, stick, book, hammer, baseball glove and ball, toothbrush, paintbrush, eyeglasses, two-by-four and computer—with 1,000 separate coats of paint, each coat being tallied and marked on a graph, consumer-product-testing style.

The suitcases they prefer for their sculptures were all made by Samsonite from the late 1940s to the early 1960s, in various designs and colors but always from the same mold, making them conveniently stackable. And they can be collected in abundance from any thrift store. Even when combined into the monumental *Suitcase Arches* (1990, pl. 146) they never lose their world-weary, seen-everything, traveling-salesman content. They exude a rootless ennui mixed with lonely sex. If they haven't been in a Hopper painting, they have certainly checked into the No Questions Asked Motel. It is this provenance that makes the Art Guys' self-portrait (fig. 6), with "Mike" and "Jack" cut into two of these suitcases and colored lights blinking on and off inside, such a poignant icon. Portrait of the artists as cheap baggage. Hello, Emmett Kelly.[10]

No matter what the Art Guys do with and to these suitcases, they never lose this accumulated content, just as the pencils they employ always remain pencils; their beer

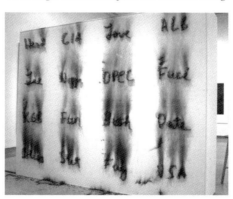

fig. 6 **Bill and Peter** 1992, suitcases, blinking colored light bulbs, house paint and electrical wiring

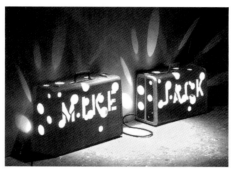

fig. 7 **English Lesson** (after burn) 1991, Sewall Art Gallery, Rice University, Houston, wooden match sticks and cannon fuse

bottles, beer bottles; carrots, carrots; telephones, telephones; and pills, pills. Theirs is an art teetering always on the edge of transformation, always approaching but never reaching that precipice. A burning match piece from 1991 called *English Lesson* (fig. 7) carries this sense of accumulated content and forestalled transformation over into words. Sixteen words are spelled out with matches in a four-by-four grid. The words are loaded in much the same way that the suitcases are:

Herd	CIA	Love	Alb
Lie	Nigger	OPEC	Fuck
KGB	Fun	Bush	Pate
Bliss	Stet	Fag	USA

When the matches are burned, the words are burned out. They look spent, but they remain loaded, as if each word carried the trace of every time it had ever been used.

A number of Art Guys routines arise from a kind of deadpan literalism. Often they involve puns, like *Wrap Music* (1992, pl. 165) (a Christogangsta-Fluxus piece), *Blue Sunday* (1984, pls. 10–12), *Total Contents* (1993) or *Go Tee Off* (1989, pls. 34–36), and sometimes they play off of the pretensions of that supposedly least pretentious art tendency, Fluxus, with faux-Flux titles like *Piano for Remote Performer* (1992) (a remake of Larry Miller's *Remote Music* performed at the Kitchen in 1979, substituting a baseball glove for the white-gloved hand) and *Piano for Falling Man* (1986, pls. 162–163). But most often, Art Guys pieces arise from a flat-footed literalization or materialization of some pedestrian idea, like *Two Grown Men Can't Pull It Apart* (1989, pls. 37–45), inspired by a turf commercial, in which the Guys went around demonstrating the truth of this on various objects from a brick to a freeway overpass to a pile of dirt, or *Appropriations* (1991–94, pls. 140–141), in which the Guys displayed objects (in glass vitrines with gold plaques) that had been "appropriated" from art world colleagues. *1,000 Coats of Paint* (pls. 132–138) is just exactly what it says, as is *The World of Wood* (1991, pls. 123–124), though this one is less realizable.

In their performances, the Art Guys display a dogged determination to continue, no matter how silly the task ahead of them. They adhere to the old vaudeville ethic of "the show must go on" as well as the performance art ethic of "the show must go on and on." In the video *Go Tee Off* (1989) the camera is fixed, gazing from a low angle up at a strip of green grass, a row of trees and a blue sky above. The only sound is the undisturbed chirping of birds. Into this bucolic proscenium steps Mike, dressed in red polyester golfing attire topped with a ridiculous yellow pompom hat and carrying a golf club. He carefully places some miniscule object on the tee and tees off. After observing its flight for a moment, he exits stage right. As Mike leaves, Jack steps into the frame, wearing a natty blue outfit. He too tees up and off. Each Guy in turn exits stage right and returns with a new object. The objects grow progressively larger. This goes on for a very long time, until the objects become almost too big to lift: a hat rack, a stuffed chair, a kitchen sink. Some of the objects explode or splatter or just collapse when hit, but the Guys go about their appointed task undeterred and with a cheerful, Tati-like purposefulness, driving the idea into the ground. The coup de grace is finally delivered by Jack, who lugs in a larger than life size suit of armor and stands it up on the tee (fig. 8). He and his club disappear behind it. With a mighty effort he whacks it in the shoulder from behind, and it teeters and falls. Jack exits. The last shot is identical to the first—green grass,

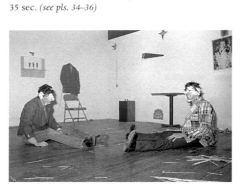

fig. 8 **Go Tee Off** 1989, image from video, 31 min. 35 sec. *(see pls. 34–36)*

fig. 9 **Huh?** 1989 (first performance), Memphis Center for Contemporary Art

trees, blue sky, birdsongs, except that now the benighted knight lies across the foreground, his visored head buried in the grass. Night falls.

The Art Guys' inquiries generally begin at a logical starting place and proceed along logical (sometimes fuzzy-logical) lines. There is an inevitability to their actions. If people love to strike small, white, pockmarked spheres with clubs while wearing silly clothes, well, why not tee off on everything one can get ahold of, from feathers to iron suits? If the most dominant feature of advertising is imminence, why not make self-promoting ads that are *all* imminence,

with slow-motion Guys on swings accompanied by Gregorian chants? If small clear marbles make a pleasing sound when rolled along piano strings, why not use a cannonball? They have carried Jasper Johns's direction to "Take an object, do something to it, do something else to it," to Pataphysical lengths, resulting in a kind of common nonsense, a working classroom art of lowbrow farce.

The Art Guys are unregenerate thieves, like all good artists. If they see an idea they like, they take it and run, without looking back. But in spite of their jackdaw thievery and wanton approach to materials, the Art Guys' performances, actions and sculptures sometimes achieve an almost classical simplicity and clarity. I find this most often in their representations of the difficulty of human communication. In their performance titled *Huh?* (1989, fig. 9), that hardworking three-letter word that the *Oxford English Dictionary* defines as "a natural utterance expressing some suppressed feeling" is used to carry the entire weight of the incomprehensibility at the heart of human intercourse. It has been performed a number of different ways, but it always begins with Mike and Jack girding themselves for the fray. Sometimes their heads are wrapped and swathed and their orifices plugged, and sometimes they strap stuffed animals all over each other before proceeding. When sufficiently armed, they begin their conversation, which consists entirely of the word "huh," whispered interrogatively, stated emphatically or screamed, back and forth in turn, with increasing frustration and intensity until both conversationalists are physically exhausted by the effort and fall in a heap on the floor.

In two related performances, *Try to Cry* (1990) and *Kiss Piece* (1992), the Guys pare their actions down to essence. In the former action, they ask for the cooperation of the audience in thinking about sad things while the Guys try to cry. They stand silently and begin to try, often provoking an uncomfortable, self-conscious emotionalism in the audience as the initial laughter trails off into confused silence. The fine line separating laughter and tears is exposed, as is the

general degradation of emotions in this age when actors who can cry on cue rule our social lives. As George Burns said, "The secret to great acting is *sincerity*. If you can fake that, you can fake anything."

In *Kiss Piece* (inspired by Emmett Williams's *Counting Songs* [1963]), the Guys announce that they would like to kiss everyone in the room. Then they proceed to do it. Now, if one *wanted* to cause problems in a roomful of strangers in Texas, a seemingly surefire way to accomplish this would be to have two lipsticked men wade out into a random crowd and start kissing everyone in sight. And sure enough, performing *Kiss Piece* recently in Corpus Christi, Mike ran into one of those men whom Rabelais named "agelasts," literally "non-laughers." This man stood trembling in fear and loathing as Mike approached him. The man told Mike that if he planted a kiss on his contorted face, he would punch him. So Mike turned around and kissed the man's wife. Then, in a show of fatherly generosity, the man instructed his teenage son to follow his lead. "If he tries to kiss you, hit him," he said. "O heav'nly foole, thy most kiss-worthy face / Anger invests with such a lovely grace / That Anger's self I needs must kiss again."[11]

fig. 10 Benefit performance in 1989 for the Alley Theatre, Houston

As George Meredith pointed out long ago in his "Essay on Comedy," "It is but one step from being agelastic to misagelastic, and the μισογελως, the laughter-hating, soon learns to dignify his dislike as an objection in morality."[12] I would suggest that this has been a significant unremarked factor in much of the recent art censorship hubbub. One of the few ways left for contemporary artists to act socially is to play the Fool. Someone somewhere once said that comedy is the expression of the spirit of the censor. The two are traditionally linked. In the past it was the clergy who pontificated against the corrupting dangers of folly. Today it is senators and congressmen.

But let us not for a moment pretend that agelasty and misagelasty are confined to the recently engorged right-wingers in Congress. At a time when there is a proliferation of bad political art, conceived as bitter pills dispensed by humorless holier-than-thou dilettantes, the Art Guys' approach provides some breathing room. Their political approach in art is con-

sistent with that of the traditional Fool. If people are uptight and fearful about a particular subject, the Fool bumbles in (fig. 10), points right at it, then points away from it, turning everything in reach upside down and backwards. Turn the cardboard signs homeless people make into etched glass art objects. Turn a shotgun house from an embattled site of "urban renewal" upside down and place it in a central public park (pls. 5–7). Sell newspapers at stoplights (pl. 1). Cut CAM's grass (pl. 2). Steal things from people in the art community and exhibit them as "appropriations" (pls. 140–141).

This approach is bound to occasionally outrage official guardians of public taste. That's in the job description. But it will also sometimes draw forth the righteous indignation of unlikely individuals suffering from temporary agelasty brought on by a sudden thinning of the skin. Take, for instance, the reviewer in the *Houston Press* who claimed that an Art Guys exhibition showed "what happens when the avant-garde imperative turns malignant and eats away at the fundamental compact between art and its audience."[13] Goodness. Now, "the avant-garde imperative" might refer to José Ortega y Gasset's idea that avant-garde art should save us from "the seriousness of life" by restoring an "unexpected boyishness."[14] But what might "the fundamental compact between art and its audience" be? Well, not to *fool* us. "Are the Art Guys playing the fools for their audience or playing the audience for the fool?" the reviewer worries. This is the question that plagues the temporary agelast: Is the joke on me or them? Who is the fool here? Are you talking to *me*? Seneca wrote, "When I want to look at a fool, I have only to look in the mirror."[15]

Look, that's what Fools are for. "Life, we know too well, is not a comedy, but something strangely mixed. . . ."[16] If life were a comedy, there would be no need for Fools. And if the work of the Fool could be marked off and segregated from the rest of life, it would have no effect. Some of the best Art Guys moments come when the gap between comedy and tragedy is temporarily bridged or at least faced. The performance titled *For Martin, Jimmy, and Bill* (1990) is best when preceded by some silly romp like *Inverted Karaoke* (1992) with

Jack singing to a recording only he can hear or trying to play the guitar and doing *The Best I Can Do* (1992). Jack then announces that Mike is going to play something for Martin Luther King, their friend Jimmy, and Mike's father, Bill, who have all died. Mike avers, "This is not really about music. It's about breathing and listening to breathing . . . and it's about stopping breathing." The crowd laughs. They laugh again when Mike raises a harmonica to his lips and begins to blow and suck and suck and blow. Mike obviously doesn't know how to play the harmonica. It's a joke, right? The Fool's a windbag. But as he continues to inhale and exhale into the harp, it gradually becomes clear that he really is playing for his father and the others who have died. The blowing and sucking do become breathing, and the limitations of his artistry suddenly become irrelevant. We all breathe. However crude, his mournful wail is true. Since it is impossible to laugh and cry at the same time, we cross over that great divide together.

So, ladies and gentlemen, this concludes our tour of the Art Guys. Though you still may not want to invite them into your homes, perhaps you've been persuaded to accord them a modicum of respect. For, while the rest of us go blithely on, one foot in front of the other, they do battle every day on the front lines of Foolishness, in the trenches of trial and error, making asses of themselves (bare at LaBare, pls. 57–60) for our sake. Sure, they're Fools, but goddammit, they're *our* Fools.

> Not knowing what to think, said Camier, I look away.
> It would seem to be lifting, said Mercier.
> The sun comes out at last, said Camier, that we may admire
> it sink, below the horizon
> That long moment of brightness, said Mercier, with its thou-
> sand colors, always stirs my heart.
> The day of toil is ended, said Camier, a kind of ink rises in
> the east and floods the sky.[17]

NOTES

Thanks to Gret, who saw it when they first sat down at our table, and to Maya Grace, who put on a fool's cap and danced. —D.L.S.

1. "The number of fools is infinite."
2. Lawndale Annex was part of the University of Houston's Department of Art.
3. Samuel Beckett, *Mercier and Camier* (New York: Grove Press, 1974), 17.
4. Mike Kelley's *Unstoppable Force vs. Immovable Object* (1977), made of a cardboard tube and two whoopee cushions, is a direct descendant of the ancient Fool's bladder-on-a-stick.
5. The non-Christian trickster figure, whether Coyote, Hare or Raven, was way ahead of all this. He often had a detachable asshole as well as a detachable phallus, two very useful features for a Fool.
6. Beckett, 21.
7. In 1991 the Art Guys made a pointed intervention in the "FluxAttitudes" show, curated by Cornelia Lauf and Susan Hapgood for Hallwalls in Buffalo and The New Museum in New York, by literally adding a page (and the last word) to the exhibition catalogue. The Guys precisely mimicked the design and printing of the catalogue and parodied its art historical language to puff their own work. In part the entry read: "FILTH has made itself present in many of THE ART GUYS' works since 1956, however it wasn't until 1959 when true harmony would become possible with the addition of half as much disdain for the unknown in relation to production. The coalescence of focus did not truly appear until 1983 when they (the Art Guys) agreed on painting by dipping their hands in buckets of paint and shaking hands in a friendly manner over a primed canvas. This mildly historic event seemed to catalyze a thought formula while at the same time cauterizing what was then an absurdly nostalgic clinging to the formulaic production of various pigments applied to usually stark white surfaces in an attempt to create a dialogue with 'viewers,' in other words, those whose ideas would have to be brought to the location of the finished product wherever it may be!"
8. Jon Hendricks, *Fluxus Codex* (New York: Harry N. Abrams, 1988), 25.
9. The best response I saw to Safer's fake-populist, aw-shucks trashing of contemporary art on TV's *60 Minutes* show of Sept. 19, 1993, was Peter Schjeldahl's Oct. 26 piece in the *Village Voice*. Schjeldahl pegged the Safer outburst as "just good old American booboisie philistinism, feeling frisky," and concluded with this pensive insight into the mind of Morley: "He seemed so proud of not knowing what he was talking about."
10. Kelly (b. 1898) created his famous tramp clown character, Weary Willie, for the Ringling Brothers' Barnum & Bailey Circus and later worked for the Brooklyn Dodgers. No relation to Mike Kelley.
11. Sir Philip Sidney, "Astrophel & Stella," LXXIII:12–14 (c. 1582), in *Selected Poetry and Prose*, ed. T.W. Craik (London: Methuen & Co. Ltd., 1965), 61.
12. George Meredith, "An Essay on Comedy" (1877), in *Comedy: An Essay on Comedy, George Meredith, and Laughter, Henri Bergson*, ed. Wylie Sypher (New York: Doubleday Anchor Books, 1956), 4.
13. Susie Kalil, "Wink Wink," *Houston Press*, March 24–30, 1994, 30.
14. José Ortega y Gasset, *The Dehumanization of Art* (Princeton, NJ: Princeton University Press, 1968), 50.
15. The supercilious Seneca, in a fit of agelasty, complained about professional fools in a letter to Lucilius: "I particularly disapprove of these freaks; whenever I wish to enjoy the quips of a clown, I am not compelled to hunt far; I can laugh at myself." Lucius Annaeuss Seneca, *Ad Lucilium Epistulae Morales*, vol. 1, trans. Richard M. Gummere (Cambridge, MA: Harvard University Press, 1961), 331.
16. Meredith, 16.
17. Beckett, 19.

Material
Differences

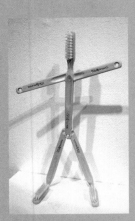

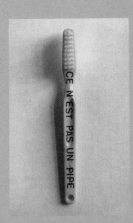

65. Ian 1991
toothbrushes
Collection Steve and Pat Lasher,
Houston

66. Pre-Colombian Toothbrush 1991
ceramic curio and toothbrush
Collection Sarah Shartle Meacham,
Portland, Maine

67. Ce N'est Pas Un Pipe 1990
toothbrush, pencils and glue
Collection Steve and Pat Lasher,
Houston

68. Brush, Brush 1990
toothbrush and dried grass
Private Collection, Houston

previous page: **Pennies from Heaven** 1992–present
Times Square, New York *(see pl. 84)*

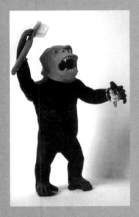

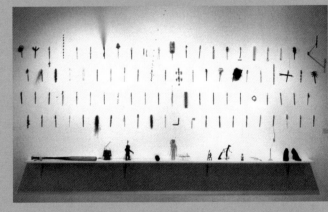

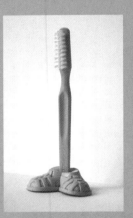

69. Kong Brush 1990
toothbrush, glue, toy gorilla and doll
Collection Steve and Pat Lasher,
Houston

70. 101 of the World's Greatest Toothbrushes (More or Less) 1990–95
Blue Star Art Space, San Antonio, 1991

71. Slim 1990
toothbrush, toy plastic feet and glue
Collection Steve and Pat Lasher,
Houston

72. One Leg Up 1995
toothbrush and toy plastic leg

73. Swiss Army Brush 1995
toothbrush, knives, utility blades
and nails

74. Triple Header 1990
toothbrushes
Private Collection, Houston

75. Hi 1995
toothbrush and toy plastic hand

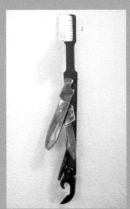

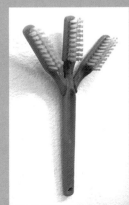

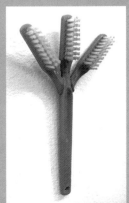

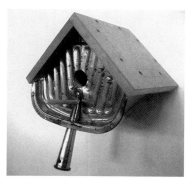

76. **Dustpan Birdhouse** 1990–91
fiberboard, maple dowel and dustpan
Collection Caroline Huber and
Walter Hopps, Houston

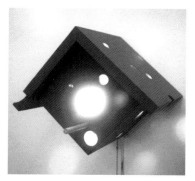

77. **Light House** 1990–91
fiberboard, maple dowel, paint and
blinking yellow light bulb

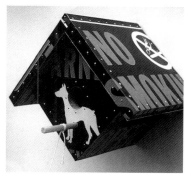

78. **Guard Dog Birdhouse** 1990–91
fiberboard, maple dowel and warning signs
Collection Caroline Huber and
Walter Hopps, Houston

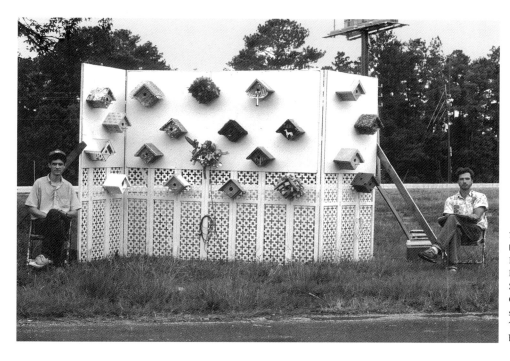

79. **Labor Day Weekend
Roadside Sale** 1991
Interstate 45 at
Holzwarth Road exit,
Spring, Texas
Operating a roadside
stand selling birdhouses.
The series included 27
birdhouses (20 pictured).

80. **Galvanized Nails Birdhouse** 1990–91
fiberboard, maple dowel, galvanized nails
and glue
Collection John Roberson, Houston

81. **Blocky Birdhouse** 1990–91
fiberboard, maple dowel, glue and
wooden blocks
Collection Paul and Maureen Massing,
Amelia Island, Florida

82. **Broken Reflective Glass Birdhouse** 1990–91
fiberboard, maple dowel, silicone and tempered
architectural glass (debris from Allied Bank
Building after Hurricane Alicia)
Collection Elizabeth Aston, Houston

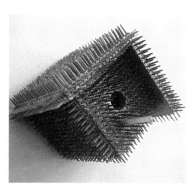

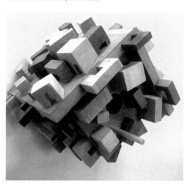

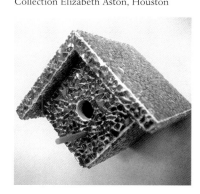

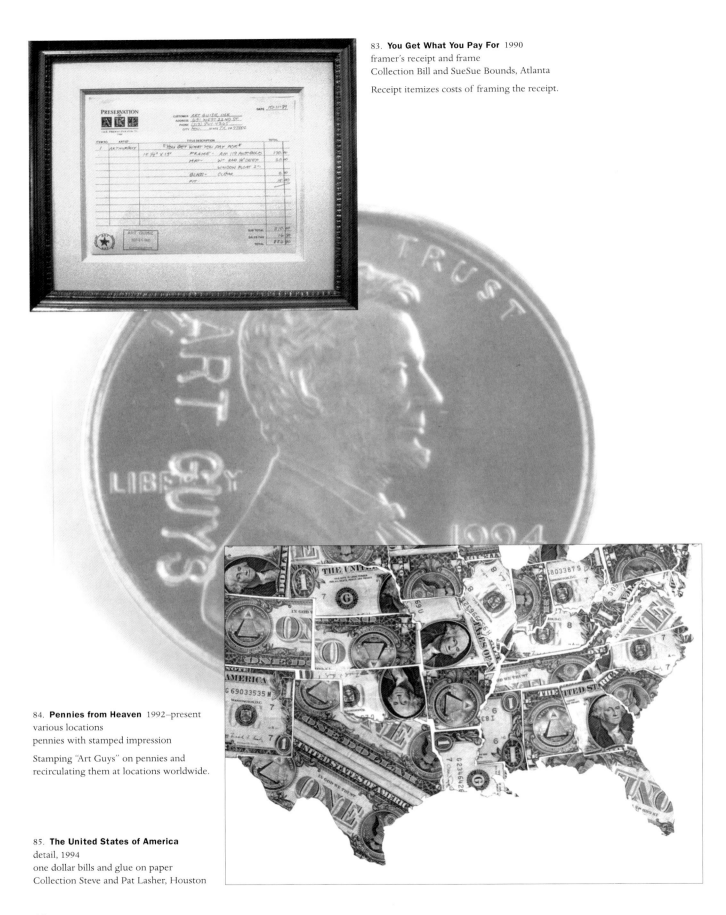

83. **You Get What You Pay For** 1990
framer's receipt and frame
Collection Bill and SueSue Bounds, Atlanta

Receipt itemizes costs of framing the receipt.

84. **Pennies from Heaven** 1992–present
various locations
pennies with stamped impression

Stamping "Art Guys" on pennies and
recirculating them at locations worldwide.

85. **The United States of America**
detail, 1994
one dollar bills and glue on paper
Collection Steve and Pat Lasher, Houston

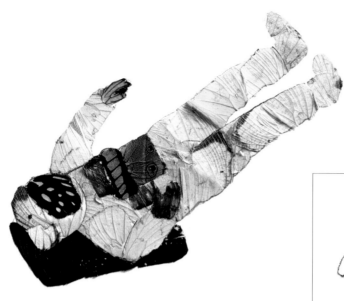

86. **Floating** detail, 1994
butterfly wings and glue on paper

87. **Aunt Bea** detail, 1994
ants, bees and glue on paper

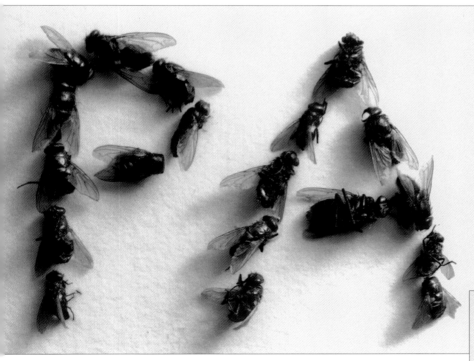

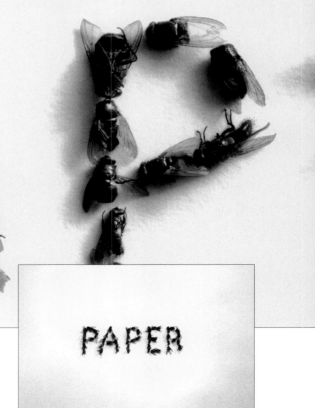

88–89. **Fly Paper** 1994
flies and glue on paper
above: detail; *right:* full view

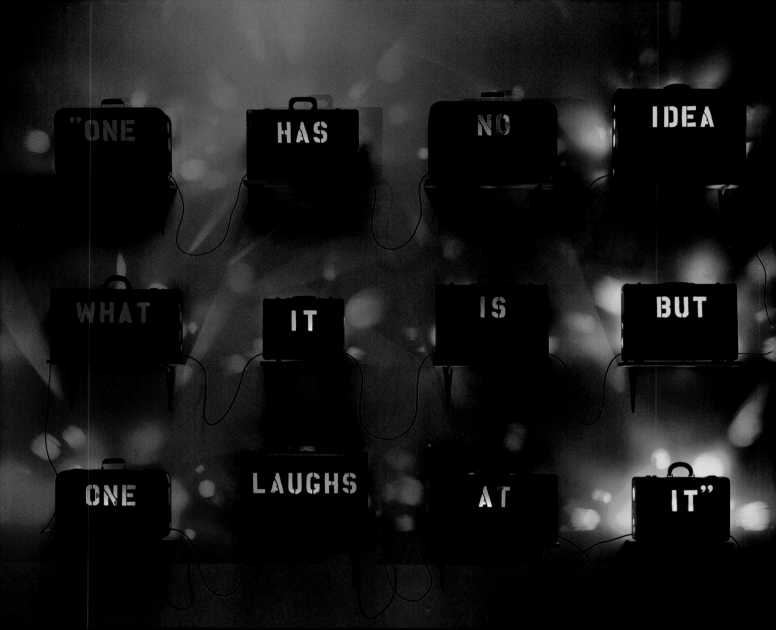

90. **The Definition of Metaphysics by Gustave Flaubert from "Dictionnaire des idées reçues"** or **The Boss Piece** 1990
suitcases, blinking colored light bulbs, house paint, wood shelves, metal shelf brackets and electrical wiring

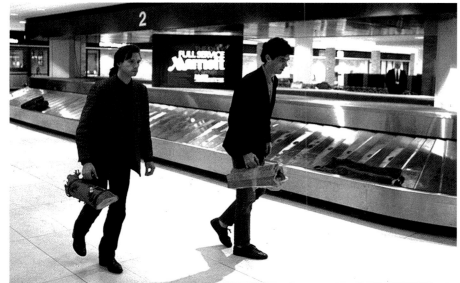

91. Travel Logs 1988
Memphis International Airport
store-bought plastic-wrapped log with handle;
and wooden log with attached suitcase hardware,
brass nails and leather handle
Collection the artists

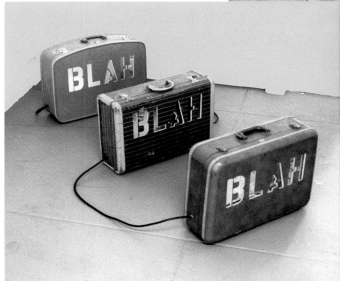

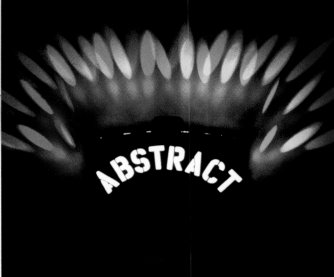

92. Blah, Blah, Blah 1992
suitcases, blinking light bulbs, house paint and
electrical wiring
Collection Nancy Reddin Kienholz, Hope, Idaho

93. Abstract 1991
suitcase, blinking
colored light bulbs,
house paint and
electrical wiring
Collection Jackie
Harris, Houston

94. Chastity (open) 1993
suitcase and electro-
mechanical parts
Collection Michael
Caddell and Tracey
Conwell, Houston

Emits cat meows and
scratching noises.

43

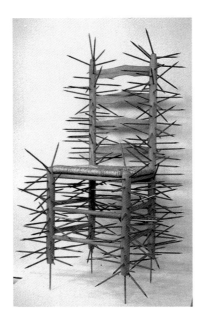

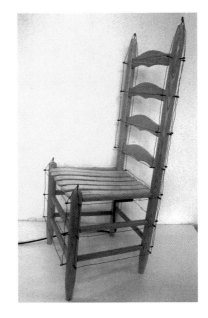

95. **Pencil Chair** 1991
wooden chair and pencils
Jay and Marta Dougherty,
Houston

96. **Electric Chair** 1992
wooden chair, wire, double-
headed nails and transformer
whereabouts unknown

Emits a mild shock when
touched.

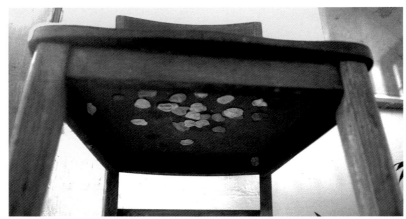

97. **Bubble Gum Chair** detail,
1990–present
chewing gum affixed to
wooden chair on mirror-
covered pedestal

Chair accumulating layers of
spent chewing gum.

98. **Bottom of the Fifth** from **The Game** 1990–91
cast liquid rubber

The Game is a series of 19 baseballs and bats made of different
materials, sets representing the top and bottom of each of
nine innings plus a set for the seventh-inning stretch.

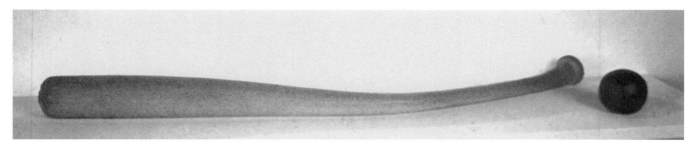

Fire
Works

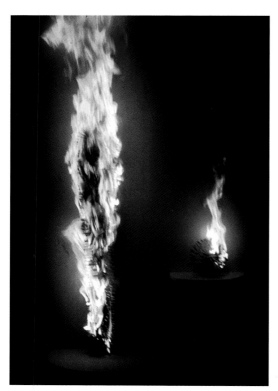

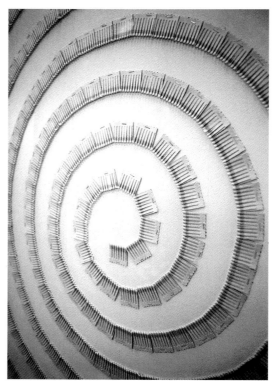

previous page: **Hammer Flambé**
(during burn) 1991
Art Guys studio
hammer and wooden match
sticks

below:
101. **Match Installation #10:
Bavarian Holiday**
(before burn) 1992
Contemporary Arts Center,
New Orleans
wooden match sticks and
cannon fuse

Match works involve covering
objects with matches or
creating vignettes by placing
matches on walls. These
works, usually ignited as
public performances leaving
burned residue and ashes,
exist only for the duration
of exhibition.

99. **Top of the Seventh** from **The Game** (during burn) 1990
(see pl. 98)
Blue Star Art Space, San Antonio
baseball, baseball bat and wooden match sticks

100. **Match Installation #3: Spiral** (before burn) 1991
Gallery 3, Huntington, West Virginia
matchbooks and staples

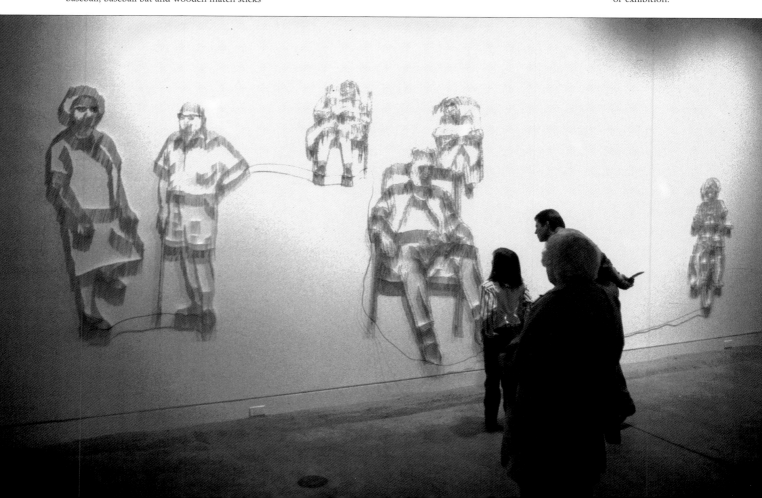

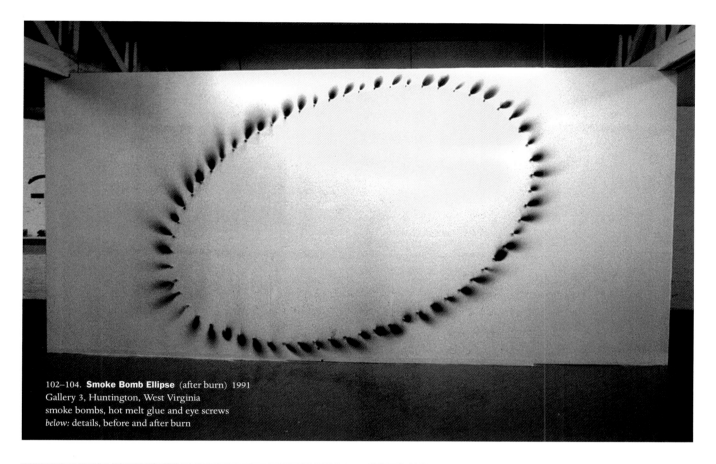

102–104. **Smoke Bomb Ellipse** (after burn) 1991
Gallery 3, Huntington, West Virginia
smoke bombs, hot melt glue and eye screws
below: details, before and after burn

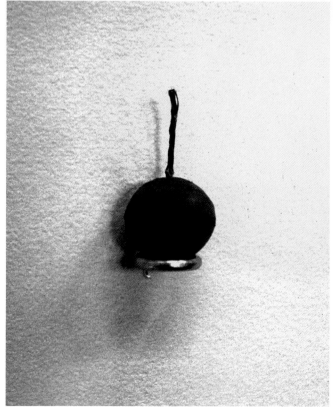

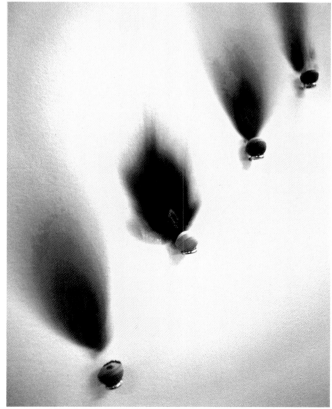

105–106. **Ashes of the American Flag Rearranged into Three Other Easily Recognizable Symbols** 1990
ashes of three American flags and spray adhesive on paper
Collection Ian Glennie, Houston
below: detail

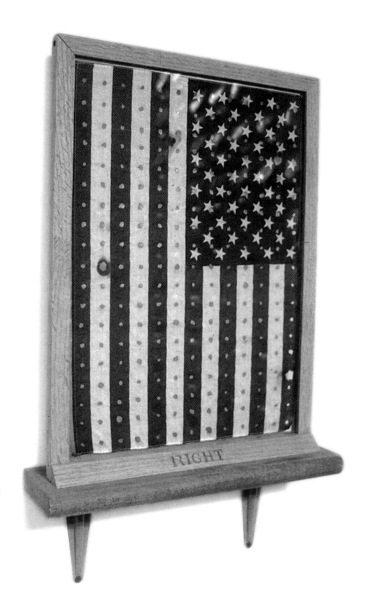

107. Right 1989
American flag, graphite, wood and glass
Collection Robert Campbell, Houston

Flag burned by sunlight focused
through a magnifying glass.

108. Twelve Gauge, Double Aught Buck, Nine Rounds 1988
shotgun buckshot holes on paper
Private Collection, Houston

109. If the Flucks Fux, Fuck Flux 1988
.25 caliber pistol, shell casing, copper slug and Fluxus pamphlet
with bullet hole through cover photograph of George Maciunas

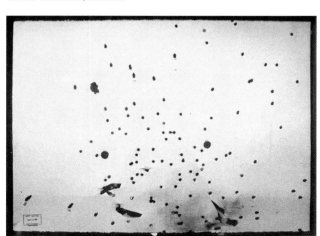

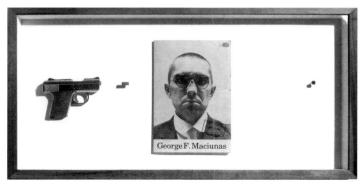

110–111. **Match Installation #8: Astronaut**
(after burn) detail, 1992 *(see pl. 101)*
Art Guys' studio
wooden match sticks and paper matchbooks
right: (full view, before burn)

112–113. **Match Installation #11: Bears** (before burn) detail, 1993
UAA Gallery, University of Alaska, Anchorage
wooden match sticks
below, right: (full view, during burn)

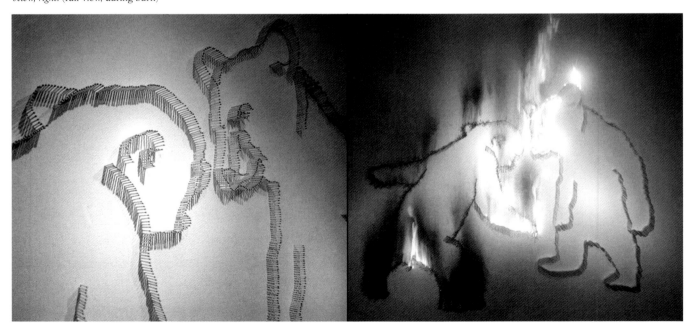

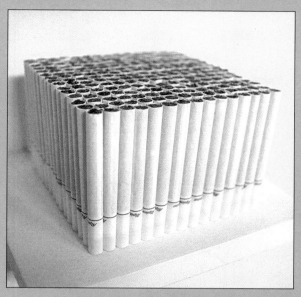

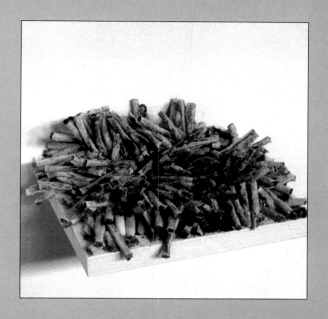

114–115. **Cigarette Bundle** (before and after burn) 1992
Art Guys studio
cigarettes and glue

116. **Miniature Bedroom Scene** (before burn) 1992
Art Guys studio
wooden match sticks and glue

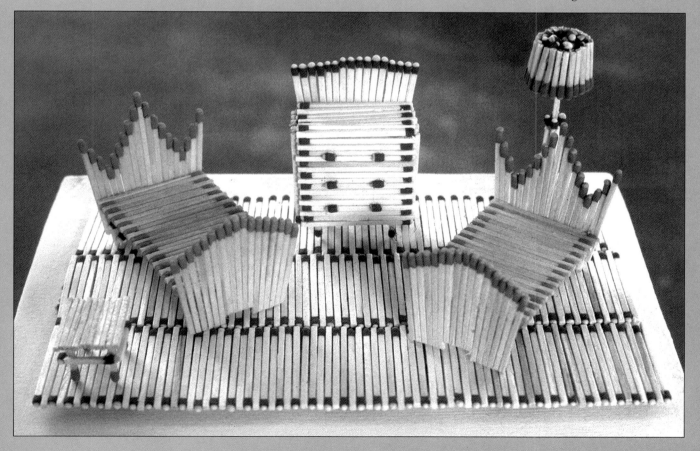

For the past 13 years, the Art Guys have intrigued, entertained, puzzled and moved those who have come into contact with their art. As a quick sampling of their work reveals, they have thrown out the first pitch at a major league baseball game, created sublime sculptural objects, spent 24 hours in a booth at a Denny's Restaurant to commemorate the winter solstice and ignited museum and gallery walls to create ephemeral drawings. Whatever they do is always performed in the name of art. Their range of media, their humorous approach to art making, their role in the community, their collaboration, the name they have chosen—all of these elements combine to make the Art Guys at once accessible *and* elusive.

An inventory of the Art Guys' oeuvre attests to the prodigious nature of their output. This dizzying size and range place the Art Guys within a continuum larger than just art history. There is, in fact, a tradition that they fit like a glove: the colorful history of jesters or fools.

Historically, fools were employed by a royal court or a household. Their role was to provide their masters with humorous entertainment, which, more often than not, commented upon the politics and social mores of the day. The tradition lives on today; fools have simply been modernized to adapt to changing times. Today's fools are the clowns, comedians and late-night talk show hosts who play games with our current events and our cultural assumptions. Anton Zijderveld, in his analysis of folly, explains that fools hold mirrors up to society to point out the contingencies of reality, finding foolishness in our structures, in hierarchies and in our everyday lives.[1] A perfect example of this is the Art Guys' *Blue Sunday* (1984, pls. 10–12), which involved their standing on the front steps of City Hall in Houston and selling each other goods banned for sale on Sundays by the state's "blue laws." Included among the contraband were nails, a mirror, bed sheets, boots and itemized cooking utensils. The Art Guys were using their own form of absurdity to draw our attention to an outdated institutional absurdity. The union of art and folly has historically been problematic, but the Art Guys have charted a steady and unbending course through these turbulent seas.

Fools' Paradise

LYNN M. HERBERT

Traditionally, fools have been highly opportunistic, and the Art Guys, following suit, are shameless self-promoters. At a certain point, they intentionally set out to achieve fame (or infamy) in the hopes that it would enable them to financially realize more works. Rather than take the reclusive artist-in-the-garret route, the Art Guys have chosen a path blazed by their fellow champion of the everyday, Andy Warhol. For Warhol, making it as an artist called for self-promotion, entrepreneurial endeavors and social involvement. Since 1987, the Art Guys have passed out business cards for all occasions (pl. 4). Cars around the state sport their bumper stickers (figs. 1 & 2), and gold plaques abound documenting their feats. The Art Guys World Headquarters churns out press releases and invitations to event after event. One particularly active month, June 1990, was declared "International Art Guys Month." Houston Mayor Kathy Whitmire declared June 9, 1990, "Aaart Guize Day," the Art Guys presented an evening of performance at the Heights Theater, and they organized an exhibition titled *See Through Us: A Survey of Portraiture Under the Guise of Art* at Treebeards Restaurant for which 95 artists prepared portraits of the Art Guys (pl. 62).

Through the years, an Art Guys persona has evolved. Their self-promotion and multitudinous public activities, coupled with their living together in the very public Art Guys World Headquarters, have made this inevitable. A recent discovery playfully suggests that their collaboration might in fact have been destined. In 1994, Michael Galbreth and Jack Massing discovered that in January 1960 their parents had taken birthday photographs of their sons wearing cowboy outfits within 48 hours of each other (figs. 11 & 12). Galbreth was four years old and living in Asheville, North Carolina. Massing was one year old and living in Tonawanda, New York. For any other two adults, such a discovery would be dismissed as mere happenstance. The Art Guys, however, elect to ponder the possibility of these photographs representing the first "Art Guys" work.

Galbreth and Massing met 22 years later as art students in Houston. Both were in their twenties and shared the background of growing up in large middle-class families in suburban America. Within a week, they were working

together on art projects. They have been collaborating ever since as the "Art Guys."

When questioned about the origin of their name, the artists explained that at the time a friend in Seattle would call himself a "hungry guy"when he was hungry and would call himself a "sleepy guy" when he was tired, and so on. Later, in 1983, the two decided to "agree on painting" by sticking their hands in buckets of paint and shaking hands (cover and back cover). Afterwards, Massing said, "I guess now we're Art Guys." The name stuck and has served the artists well.

The "Art Guys" has a nice ring. It's easy to remember, has an element of humor and makes them seem accessible. Any spelling of the name is all right with the artists as long as it is phonetically correct. This allows for word play (Art Guise), humbug (Art Guyz) and the assurance that they will be listed first in group exhibitions (Aaaart Guys). Although a stage name has forced the Art Guys to relinquish their individuality, it has also emboldened them and given them greater freedom when doing things under the countenance of art. That there are two of them also helps in this regard because it is harder to categorically dismiss something if two people are involved—it implies that they know what they are doing.

The Art Guys' celebrity has led writers to probe and try to reveal their individual identities. Galbreth has been called "the tall, lanky Art Guy," "the theoretician" and the one who is "more oriented toward 'behavioral' work." Massing has been called "the smaller Art Guy who bears a faint resemblance to James Dean," "the funny one" and the one who is "more attuned to materials and the physical qualities of art making."[2] Astonishingly, despite the probing, the Art Guys' egos remain for the most part hidden, and their pure form of collaboration (linked together only as colleagues) has flourished. Given the nature of their work, they themselves have become ongoing creations: their daily

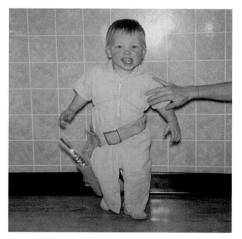

fig. 11 Jack Massing, age 1, birthday snapshot, January 4, 1960, Tonawanda, New York

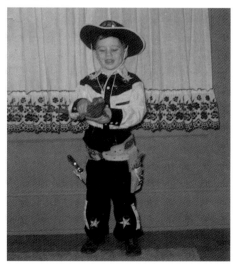

fig. 12 Michael Galbreth, age 4, birthday snapshot, January 6, 1960, Asheville, North Carolina

behavior has become inextricably linked to their art. To the uninitiated, it is hard to tell when the Art Guys revert to being simply "Mike" and "Jack." And to some extent, the collaborative persona has come to dominate their lives.

When the Art Guys renovated a turn-of-the-century mattress factory in Houston for their Art Guys World Headquarters, the neighborhood association immediately asked them to become a part of their spring home tour.[3] Since 1990, the Art Guys have presented 21 exhibitions there, more than half of which were dedicated to the work of other artists. They have become arts ambassadors for the city, organizing programs for groups throughout Houston and hosting benefits and out-of-town arts groups. They are diligent about participating in community events such as the annual Art Car Parade (fig. 20). And their efforts have reached far and wide: to Tiffany's windows, a Denny's Restaurant, the airport, the Astrodome and the roadside, as well as galleries and museums.

The playful and nurturing nature of the Art Guys and their work has had an important impact on the surrounding arts community. Other contemporary artists, including Mierle Ukeles and Tim Rollins and K.O.S., have also chosen to interact with particular segments of their communities. Ukeles has worked with the New York City sanitation department and Rollins with children living in the South Bronx. The Art Guys, however, operate from a unique position as artist jesters.

Everyday life is the Art Guys' playing field, providing them with a bounty of materials. Certain elements have achieved iconic status in their oeuvre. Some of these are identifiably American—baseballs and bats, the stars and stripes, American currency and the NASA space program. Others are more universally mundane—toothbrushes, cigarettes, golf, suitcases, airplanes, pencils and marbles. Still others, including beer bottles, smoke bombs, drugs, pornography

and facial hair, reflect a penchant for stereotypically male juvenilia.

The Art Guys capitalize on their audience's intuitive recognition of these objects and institutions. They use them to seduce their audience into a dialogue. Jasper Johns saw metaphysical potential in beer cans, maps and flags. He employed them as a point of origin from which to explore the notion of painting. The Art Guys instead allow the objects to stubbornly retain their identity.

Penny Column (1992, pl. 152) is a single column of pennies that begins on the floor and rises to the ceiling. At first glance it is an elegant line, like a single flourish of a pen. Closer inspection reveals that it is instead an army of tarnished infantrymen of the lowest monetary order, mounting a laborious assault to the ceiling. The work effectively moves from the sublime to the ridiculous and along the way raises questions about quantity, value and economics. It is a gentle but effective seduction.

The *Suitcase in Space Project* (1988, pls. 26–27) is as bloated as the *Penny Column* is lean. The Art Guys' homage to lost luggage is composed of assorted collaged charts and photographs, printed statements, a shaving kit, a tin globe and a weathered suitcase. The work explores our relationship to several related aspects of contemporary life: suitcases, travel and the exploration of space. It bombards us with its absurd humor. A statement from the Aesthetic Rocket Technology Guys, Inc. (A.R.T. Guys, Inc.) declares:

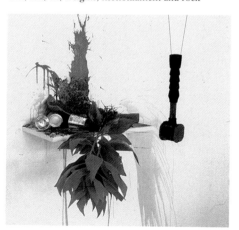

fig. 13 **Untitled** 1985, Hiram Butler Gallery, glass, dirt, salt, oil, weights, monofilament and rock

fig. 14 **101 Catastrophes** 1990, brass hammer and various smashed objects

"Scientists have long been concerned with the comfort and appearance of astronauts as they endure long and often uncomfortable conditions in outer space. Who can forget the haggard looks of the early Gemini astronauts as they first emerged from their capsules? When millions of people saw their unshaven faces, letters flooded NASA imploring the nation's leading scientists to give those guys a decent razor, for heaven's sake!" [4]

The Art Guys' well-stocked shaving kit jokingly suggests how NASA might better meet its astronauts' travel needs. A Samsonite suitcase, made space-ready with gold leaf and reentry tiles, hovers "in space," orbiting earth. NASA diagrams reveal, for the first time, that there is lost luggage adrift in space. And two fully suited astronauts approach their spacecraft carrying unwieldy suitcases loaded with the comforts of home, thanks to the Art Guys, who promise: "More sophisticated models in the future will include whole wardrobes complete with slippers, smoking jackets, and cordless electric toothbrushes." [5]

As befits fools, humor is a constant in the Art Guys' work. Their form of satire is endearing because, rather than laughing *at* us, they are laughing *with* us—albeit with a certain edge. And like Joseph Beuys, the Art Guys are able to laugh at themselves. "It's not Jonathan Swift, it's Dave Barry." [6]

Chastity (1993, pl. 94) is a banal-looking suitcase that intermittently emits meows and scratching sounds as if a cat were locked inside. For *International Catastrophe* (1987), the artists drop a platter holding a roasted fowl and pronounce the Fall of Turkey, the Breakup of China and the Loss of Greece. The Art Guys' humor may appear in various forms, high and low, but it is always intuitive and accessible, contributing to the broad appeal of their work. Common everyday experience holds sway against the often recondite imperatives of art history.

Humor may be a cornerstone of foolery, but it has generally been suspect in the history of art. In today's art climate, so dominated by contentious postmodernist discourse and self-righteous political correctness, the Art Guys' irreverent humor is both problematic *and* welcome. Food for thought can be found in a favorite book of the Art Guys, *The Cokesbury Stunt Book: More than 500 Stunts for the Stage, Banquet, Luncheon, Party, Boy's Camps and Other Occasions* (1934). The

author, Arthur M. Depew, sought the following for his book: "I hope that the suggestions contained in it will result in producing entertaining and wholesome programs, and that the burden of life will be lightened and our courage to meet the more serious problems of life will thereby be renewed."[7] Or, as the artist/author Robert Adams recently wrote: "Mark Twain said that analyzing humor was like dissecting a frog— both die in the process. These days we want to try to let them both live."[8]

From 1982 to 1988, the Art Guys created a number of careful works exploring systems of world order involving time, astronomy, solstices and equinoxes (fig. 13). Their precise approach to such systems, however, changed with *Dining at Denny's: Food for Thought* (1988, pl. 3). For this work, the Art Guys spent 24 hours in a booth at a Denny's Restaurant in observation of the winter solstice. Although the appointed day was determined by the scientific demarcation of the solstice, the rest of the piece was anything but predictable. The rhythms of life in a coffee shop took over, with intermittent visits from curious members of the media.

Since then, the Art Guys have behaved like any other self-respecting fools and have focused their energy on *irreverence* for order and systems. They find particular delight in playing with chance, catastrophe, chaos and wrongheadedness. Relinquishing control of individual works is a logical extension of their inherent relinquishing of control by collaborating.

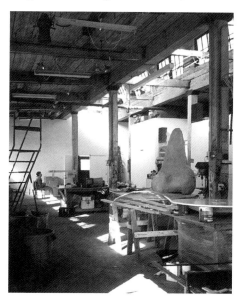

fig. 15 Art Guys World Headquarters, interior 1995

Many of their performances are unrehearsed and contain an element of chance indicative of the endless possibilities inherent in everyday life. In *Try to Cry* (1990), the artists announce to their audience that they are going to try to cry and ask for silence, please. The initial hearty laughter from the audience turns to nervous giggles as the minutes pass by with the artists quietly trying to cry. What personal sadness are they evoking to conjure tears? Massing's lower lip starts quivering convincingly and his eyes glisten with tears. After a few more minutes, Galbreth shakes his head and calls off the performance. He can't cry.

A small shelf in the Art Guys' studio was the location for *101 Catastrophes* (1990, fig. 14). One by one the artists placed 101 objects on the shelf (flashlight, potted plant, can of paint, piece of glass), and each time a swinging hammer came in for the blow, imprinting residual material and precipitous splatters on the shelf and surrounding wall.

Fire is a favorite tool of the Art Guys for creating chaos. In these works, serendipity often takes over, with beauty emerging from destruction. In 1990, the Art Guys began making small sculptural pieces and works on paper from matches, smoke bombs and cigarettes (pls. 114–116). These led to an ongoing series of large match works for walls. Line drawings are created by painstakingly affixing books of matches or individual match sticks to a wall (pls. 100–101, 110–113). With the strike of one match, these Herculean constructions fall like dominoes in a row as each match ignites its neighbor. Audiences who view the transformation at openings experience instinctive shivers of fear as gallery walls are set aflame. The original drawings are physically and metaphorically transformed by the whims of the fire, which leaves behind ephemeral smoky traces.

Wrongheadedness, the stubborn adherence to clearly erroneous opinions or principles, has become an Art Guys credo. It fuels their penchant for seeing what will happen if you do the wrong thing and enables them gleefully to step over boundaries and see where they wind up. Their wrongheaded activities range from slipping a *soupçon* of gratuitous sex into an otherwise beautiful drawing (pl. 118) to more theatrical examples. In *Drop Stuff on Mike's Head* (1990, pl. 20), Galbreth dons scrubs, a helmet, protective glasses and ear plugs before sitting in a chair. Massing then climbs up a ladder placed directly behind the chair and proceeds to drop stuff on his fellow artist's head: eggs, a golf club, a bouquet of roses, a girlie magazine, Cheerios, a can of baked beans, flour, beer. . . . Some items elicit laughs, and others, gasps, but all leave a big mess. There is an element of shock value, but as the artists have pointed out, their use of shock value is more akin to the Everyman comedian Jerry Seinfeld than masochistic punk rocker Sid Vicious.

Fools are never impressed by power and authority, and the

Art Guys relentlessly and humorously challenge established rules and order.[9] For their exhibition at CAM, they proposed *Name Change*, which involved changing the name of the Contemporary Arts Museum (CAM) to Contemporary Art Guys Museum (CAGM) during the course of the exhibition, altering signage, the stationery and even how the receptionist was to answer the telephone. They also proposed *Watch What You Say*, which would allow visitors to listen in on any phone conversations taking place within the museum. Such proposals are like good-natured taunts, the Art Guys daring the establishment to step over the line. Though unwilling to accommodate *Name Change* and *Watch What You Say*, the museum *has* agreed to facilitate *Googly Eyes for CAM* (1995), two giant googly eyes for the façade of the building, and *On Guard* (1995), a series of costumes and accoutrements to be worn by the security staff including oversized clown shoes and futuristic toy laser guns.

The Art Guys have a dilettantist interest in science that often influences their working method. The Art Guys World Headquarters has the air of a laboratory for science projects (fig. 15). The artists' sketchbooks document a myriad of ideas, some realized and others not (figs. 29 & 30). Their pursuits are open ended: they enjoy the experimentation as much as discovering the end result. The time and labor involved become integral to the work and allow the artists to refine

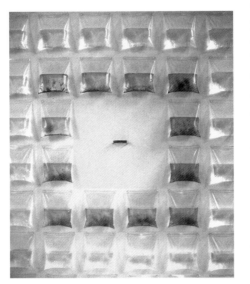

fig. 16 **Untitled** detail, 1990, tap and bayou water in Ziploc bags, push pins and toy lead boat on glass shelf

their goals along the way. Projects are laid out on each table like so much empirical data. Visitors can monitor progress and view the steps as they lead to the final product.

For one project, the Art Guys explored ideas about paint. Galbreth had been painting walls at The Museum of Fine Arts, Houston, and realized that with the successive layers of paint applied for each exhibition, the museum was, in fact, getting smaller. From a buildup of paint it was a simple step to explore how a snail creates its shell, and soon they were wondering what 1,000 coats of paint would look like. All of these thoughts led to *1,000 Coats of Paint* (pls. 132–138), which they worked on from October 23, 1990, to May 11, 1991. For this project, the artists applied 1,000 coats of paint to 12 objects: a paintbrush, a hammer, a teddy bear, a telephone, a

book, a piece of two-by-four lumber, a baseball glove, a baseball, a toothbrush, a wooden stick, a pair of eyeglasses and a computer keyboard. A detailed chart documents the color of each successive layer. During the long course of coating the objects, the Art Guys gained a new respect for the properties of paint and its allure for painters. The heavily coated finished objects are presented on glass so that viewers can verify the identity of the original object from the underside and get a sense of what 1,000 coats of paint looks like. Ironically, after layering on every imaginable color, the artists chose gray for the last coat. Thus, the finished objects are mysterious gray lumps concealing an object and a veritable rainbow of color within.

In a more biological vein, for an untitled work from 1990, a ten-foot grid of Ziploc bags was stapled to the wall with a toy boat resting on a shelf in the center (fig. 16). The bags along the outer and inner perimeters were filled with bayou water, and the remaining bags were filled with tap water. Light played an important role in animating the work. Over time, the bayou water turned green with algae, adding an element of evolution as well as painterly color to the work.

Although now in their mid to late thirties, the Art Guys show no signs of shedding their penchant for boyhood juvenilia. All of the paraphernalia is there: marbles, beer bottles, cigarettes, smoke bombs, drugs, girlie magazines, matches, pencils, mixed drinks and a fascination with facial hair. Sex is sprinkled about gratuitously. In *Kiss Piece* (1992) the Art Guys step down from the stage and kiss everyone in the audience. Another work, *Skip the Next Piece* (1990), sometimes precedes *Take All Your Clothes Off* (1994) on the performance program. Sometimes it doesn't.

The Art Guys also revel in their boyhood love of product testing. In *Beat It, Burn It, and Drown It* (1987, pls. 21–25) they took a book titled *Beat It, Burn It, and Drown It* and did precisely that. In *Rock Drop: Catastrophe Theory No. 6* (1985, pl. 17), the gold plaque on the glass-encased shattered rock tells it all: "Rock Drop, Catastrophe Theory No. 6, October 9, 1985, Houston, 5 drops at 15 feet." This was followed up by *Rock Drop: The Video* (1988, pl. 16) for which a television monitor

playing a videotape of a rock was dropped from the roof of a building by stunt man Red Trower during *Stunt Nite*, an evening of performance organized by the Art Guys for The Orange Show, a folk art environment that sponsors art and music events in Houston.

In 1987, the Art Guys needed to make a work that could travel to an exhibition at Blue Star Art Space in San Antonio. They strapped and bolted a suitcase to the back of their truck and dragged it the 234.7 miles from their studio to Blue Star, creating *Product Test #1: Suitcase Drag* (1987, pls. 28–31). At the outset, they were flagged down and stopped so frequently by concerned passersby, including officers of the law, that they eventually attached a sign to the back of the truck that said "PRODUCT TEST." They also set out to collect all of the roadkill they passed. The quantity and odor soon became overwhelming, however, and they were forced to abandon this aspect of the project, burying their collection by the roadside.

Dedication and a commitment bordering on the obsessive can be found in many Art Guys works. Such qualities are generally revered in artists, and the Art Guys characteristically toy with that reverence by presenting their more obsessive works in a self-mocking light.

101 of the World's Greatest Sculpture Proposals (1989–present, pls. 117–119, 147, 154) is a series of works on paper that document sculpture proposals the Art Guys would like to some day realize. The works include drawing and collage, and each one is spiked with numerous sidebar puns and gags. The title of the series is pure Barnum & Bailey, adding an element of tongue-in-cheek grandeur to their quest for "one hundred and one." *The Big Sneeze* (1991, pl. 119) from this series includes engineering drawings for an enormous nose that would sneeze periodically, a package of Kleenex, a collage of a mountain climber scaling Abraham Lincoln's nose at Mt. Rushmore, a statue of the Virgin Mary with her nose chipped off and a gag rubber nose, among other things. The Art Guys have realized *The Big Sneeze* (1995, pl. 120) for this exhibition.

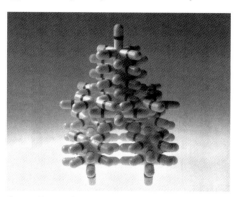

fig. 17 **Acetaminophen Structure** 1993, acetaminophen capsules and glue

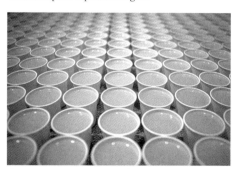

fig. 18 **24 Quarts of Tang** detail, 1993, 5 lb. 3 oz. container of Tang and 256 three-ounce paper cups filled with Tang

The *Appropriations* series (1991–94, pls. 140–141) is a group of elegantly presented and meticulously documented items the Art Guys have stolen from various museum directors, gallery owners, patrons and artists over the course of four years. Included in the booty are a miniature cello, a coffee mug, a Michael Tracy sculpture and a sock.

Bulk Up for CAM (1994–95, pls. 57–60) is another work realized for the exhibition at CAM. In May 1994, the Art Guys took a "before" photo and proceeded to work out with weights regularly for almost a year. At the time of the exhibition, they took a companion "after" photo and unveiled their body sculpting with a performance at LaBare, a ladies' club in Houston that features male strippers.

"Quantity has a quality all its own" is a favorite mantra of the Art Guys, and many of their works reveal their fascination with numbers, number structure and quantity's relationship to our consumer society. Drawing from their signature palette of materials that are economically cheap but metaphorically rich, the Art Guys have created a playful dialectic: the materials stubbornly retain their identity yet also become part of grander schemes. Other artists, including Arman and Donald Lipski, have explored this arena. Aesthetic doctrines of modernism collude with the social agenda of postmodernism to create a pendulum swinging between form and content. Individual works fall along the pendulum's arc at different points, some more about form, others more about content, with still others balancing precariously in the middle. Thrift enhances the charm of these works, and like the Art Guys' "fire works," the pieces exploring quantity have a serendipitous beauty.

Many of these works explore the structural integrity of common objects, allowing their shape and strength to suggest and determine form and scale (fig. 17). For the series *Bonded Activity* (1990–93) the Art Guys created spheres, trapezoids, hexagons and model buildings out of pencils (pls. 8, 144, 153, 155). On a larger scale, the Art Guys have also made

spheres, capsules and towers out of beer, water and soda bottles (1991–94, pls. 142, 145).

24 Quarts of Tang (1993, fig. 18) utilizes a grid format on the floor. A five-pound three-ounce container of Tang, which promises "Twenty-four Quarts of Tang," sits regally on a shelf overlooking 256 three-ounce paper cups filled with Tang. The work bombards viewers with Tang's singular color and suggests any number of ironies including "Shouldn't 'orange juice' go bad?" and, again, "Is this the best we could do for our astronauts?"

The Art Guys completed three bodies of work in 1990–91 that explored the concept of variations on a theme within certain limits. In *The Game* (pls. 98–99), the Art Guys made 19 baseballs and bats, one for the top and bottom of each inning, with an added pair for the seventh inning stretch. Each "inning" was made out of different materials including pennies, feathers, matches, rubber and glass. Concurrently, they made 27 birdhouses (pls. 76–82) for a roadside sale starting with a uniform model wren house whose plans they found in a child's book. The birdhouses were covered with everything from American flags, pencils, anchovies and yardsticks to lava rocks, mirrors, bottle caps and a dust pan. With *101 of the World's Greatest Toothbrushes (More or Less)* (pls. 65–75) the Art Guys were able to take the "variations on a theme" idea even further because the toothbrush pieces were smaller, cheaper and easier to realize quickly.

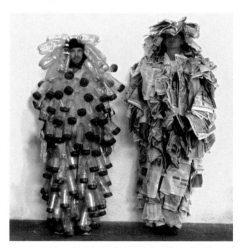

fig. 19 illustration from B.J. Griswold's *Crayon and Character*, 1913

fig. 20 **Seltzer Bottle Suit** (made by Gene Pool) and **Newspaper Suit**, 1993, worn in *Roadside Attractions: The Art Car Parade*, Houston

Wiith the entire world as their playground, the Art Guys are just as likely to find inspiration at a Fiesta Food Market as in the pages of *Artforum* magazine. Several volumes in the Art Guys World Headquarters library are of particular importance to the artists. B.J. Griswold's *Crayon and Character: Truth Made Clear Through Eye and Ear or Ten-Minute Talks with Colored Chalks* (1913) appeals to their appreciation for dated and simple humor (fig. 19). The aforementioned Cokesbury *Stunt Book* has in-

spired numerous Art Guys performance works including *How To Turn a Boy into a Glass of Water* (1988) and *Hong Kong King Kong Ping Pong Sing Along* (1992). *Behind the Scenes at Consumer Reports Desk Calendar 1988* fuels their penchant for product testing. And *Hoaxes, Humbug and Spectacles* (1990) is filled with the antics of such Art Guys mentors as Harry Houdini, Daredevil Diavolo and Zacchini The Human Projectile.[10]

Art history has its own roster of showmen who have made a place within the arts possible for a phenomenon like the Art Guys. Marcel Duchamp opened doors for countless artists with his playful intelligence, his irreverence and his interest in showing common objects standing for ideas and having a presence all their own. Duchamp would have felt right at home at the Art Guys World Headquarters. There he could find a pickup chess game, compare notes with the Art Guys on how best to present a peep show or talk about the artistic potential of suitcases or hair; *Mrs. Mike* (fig. 21) and *Rrose Sélavy* probably would have had quite a bit to say to each other.

Duchamp's fellow Frenchman, Yves Klein, worked as hard on developing his persona as Warhol, Duchamp or the Art Guys. Like the Art Guys, Klein felt that ideas belong to no one. Rather, "(t)hey pass from mind to mind as coins pass from hand to hand."[11] Klein, too, was reluctant to give up boyhood passions (knights and the quest for the Holy Grail), and he shared the Art Guys' interest in fire as a component for art making. One of the Art Guys' *101 of the World's Greatest Toothbrushes* is awash in Klein's signature color, International Klein Blue. And Klein's ultimate stunt of jumping "into the void" serves as a landmark in the annals of wrongheaded stunts. Perhaps the Art Guys' *Chip Dip* (1988, fig. 22) in which Jack hurls his body into a vat of chips is the Art Guys' way of taking Klein's jump further into the realm of the absurd.

Chris Burden has also excelled in the realm of persona-building stunts. One critic went so far as to call him the "Evel

Knievel of art."[12] Burden's stunts share some of the Art Guys' juvenile fascination with product testing, but in Burden's case, he was burning, shooting, drowning, stabbing and electrocuting *himself,* thereby drifting into masochism and sadism. The Art Guys have chosen to portray their angst in a more endearing light (fig. 20).

In 1965, George Maciunas, the ringleader of the then burgeoning Fluxus movement, described the movement as "the fusion of Spike Jones, Vaudeville, gag, children's games and Duchamp."[13] The Art Guys were children then, but Maciunas was talking their language. The Fluxus artists made art that was subversive, irreverent, humorous, witty, intelligent and egalitarian. They were interested in circumventing traditional venues and closing the gap between art and life. Everyday actions were considered aesthetic acts, and Fluxus artists were known for crossing media—mixing music, performance, film, objects, drawing and actions.

The Fluxus esprit permeates Art Guys activities. They created their own gallery then further circumvented traditional venues by taking their art to the streets. For *December Distribution Doubletake* (1989, pl. 1), a kind of "put yourself in my shoes" performance, the Art Guys sold newspapers on a street corner for a day. Their research and collaboration with the regular hawkers led the press to draw attention to the hawkers' organization and industry. For *Labor Day Weekend Roadside Sale* (1991, pl. 79), the artists set up a roadside display and sold birdhouses along Interstate 45. As part of the event they also spaced teaser signs in Burma Shave cadence along the highway, including "These signs are not/For laughs alone/Buy a birdhouse/Or go back home" (figs. 23–26) and "Art Guys' Art/You'll soon see 'em/Safe inside/An art museum."

John Cage had a seminal impact upon the Fluxus movement as well as on subsequent music theory with his belief that any sound could be considered music: all that was needed was someone to listen. This then radical idea is now gaining widespread acceptance. Witness the off-Broadway success of *STOMP,* the English dance/performance/music

fig. 21 **Mrs. Mike** 1990, Cibachrome print

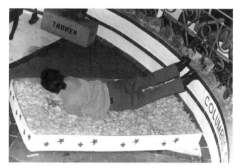

fig. 22 **Chip Dip** 1988, The Orange Show, Houston; Jack diving into a bed of chips.

troupe that makes music with such "instruments" as garbage cans, brooms, hubcaps and metal pipes.

The Art Guys embraced Cage's teaching and for years have utilized music as a hook for audiences to hang their hats on. Their "music" has taken form in scores, performance and video. To create musical scores on paper, the Art Guys have used fire, a shotgun, pool balls, googly eyes, facial hair and a lawnmower. Performances have included *Piano for Falling Man* (1986, pls. 162–163), *Music for Sideburns* (1987, pl. 164), *Untitled #7 (Lawnmower Music)* (1988, pls. 158–159) and *Wrap Music* (1992, pl. 165) in which the Art Guys use giant rolls of industrial palette wrap to create a surprising number of sounds while wrapping boxes or the audience. Video works have included *Music of the Spheres* (1986, pl. 170), *Music for BB's* (1983, pl. 169) and *Jets* (1991, pls. 171–172), a site-specific video installation for the Dallas Museum of Art that dotted the ceiling of a runway-like corridor with 16 monitors noisily documenting a jet preparing to land as seen from below.

Bruce Nauman is a kindred spirit to the Art Guys in several ways. Curator Paul Schimmel could have been writing about the Art Guys when he wrote, "For Nauman, art is made real by isolating and extending mundane activities into a commitment to learn from those activities. Only by executing an action with dedication, in an almost obsessive desire to explore all the possibilities, can the 'true artist' come to learn from the activity of making art."[14] Like the Art Guys, Nauman works in a variety of media, and certain ideas often will cross into different media. Word play is another recurring thread they share. Nauman's intense neon word pieces are an interesting contrast to the Art Guys' more economically realized and deadpan suitcase works with cutout words and colored light bulbs (pls. 90, 92–93). More word play can be seen in the Art Guys' *Go Tee Off* (1989, pls. 34–36) and *Goatee Off: Manifest Destiny* (1991, pl. 9). *Go Tee Off* is a performance work in which the Art Guys, golf clubs in hand, teed off on a series of objects of increasing size (from dice and a loaf of bread to an easy chair and a full suit of armor). *Goatee Off:*

Manifest Destiny is a collage made from pages of U.S. postage stamps in which Buffalo Bills' goatees have been painstakingly cut out and placed on Red Clouds' chins.

Collaboration has a long history in the visual arts, but it seems to have become particularly fashionable in recent decades. Komar and Melamid, Ginzel and Jones, Fischli and Weiss, McDermott and McGough, Clegg and Guttman, Gilbert and George, Erickson and Ziegler, General Idea, MANUAL and TODT are but a sampling. Among collaborative teams, the Art Guys are most closely akin to Fischli and Weiss, whom the Art Guys call "the Swiss Art Guys." They too are engaged in serious play in a variety of media and share the Art Guys' interest in chaos, order and the comical side of metaphysics. No material is too humble for Fischli and Weiss, who, for one work, dressed up sausages. The two collaborative teams differ, however, in that Fischli and Weiss's use of the everyday tends to be more art historical and dry. The Art Guys keep more firmly rooted in the everyday, thus making their work that much more accessible.

In his book on the history of fools, Zijderveld observes: ". . . the more abstract a society grows, the larger the chance will be that various groups of people begin to long for re-enchantment. The question is, indeed, whether human beings can live at all, for a prolonged period of time, without any kind of enchantment."[15] Zijderveld goes on to note that in the 1960s, the city of Vancouver allegedly employed a town fool, financed in part by the Canada Council.[16] The endeavor failed. Perhaps it was because the fool had no platform—no king to attach himself to, as in days of old, or (more relevant to the 1980s and 1990s) a late night television talk show to host.

The Art Guys *have* a platform: Art. What a fools' paradise—the nebulous and convoluted world of contemporary art. Amidst the hue and cry of "My kid could do that!" and "You call that art?" who better to jump into the fray than the Art Guys. Their strategies have broad appeal. Their work is universal and their intuitive approach taps into a common memory bank. With one foot in art, one in science, one in vaudeville and the fourth serving as a rudder guiding this multifarious duo through contemporary consumer society, their comical stance may seem awkward and precarious, but they have stayed this unique course for 13 years enchanting audiences all along the way.

NOTES

1. Anton C. Zijderveld, *Reality in a Looking-Glass: Rationality Through An Analysis of Traditional Folly* (London: Routledge & Kegan Paul Ltd., 1982), 27.
2. In order: Joe Nick Patoski, "Art Gile," *Texas Monthly* (May 1991): 70; Patricia Covo Johnson, "The Aaart Guys: Galbreth & Massing," *Contemporary Art in Texas* (Roseville East, NSW, Australia: Craftsman House, 1995), 20; and Susan Chadwick, "Performance 'Guys' are really pranksters," *The Houston Post*, June 25, 1990, D4.
3. The Art Guys International World Headquarters was featured on the Heights Home Tour in 1991, the year of the Heights Association's Centennial. Depending on the occasion, the Art Guys World Headquarters assumes other names, some of which are MOMAG or Museum of Modern Art Guise, Art Guise Ink, The Museum of Fine Art Guys, The New Museum of Contemporary Art Guise and The Museum of Fine Arte Guizados, Ink.
4. Taken from a text panel that is part of the Art Guys' *Suitcase in Space Project* (1988).
5. Ibid.
6. From a conversation with writer Elizabeth McBride, November 28, 1994.
7. Arthur M. Depew, *The Cokesbury Stunt Book* (1934, rpt. New York: Abingdon Press, 1953), 8.
8. Robert Adams, "Humor," in *Why People Photograph* (New York: Aperture, 1994), 21.
9. Zijderveld, 29.
10. B.J. Griswold, *Crayon and Character: Truth Made Clear Through Eye and Ear or Ten-Minute Talks with Colored Chalks* (Indianapolis: Meigs Publishing Company, 1913); Depew (see note 7); *Behind the Scenes at Consumer Reports Desk Calendar 1988* (Mt. Vernon, NY: Consumers Union, 1987); and Mark Sloan with Roger Manley and Michelle Van Parys, *Hoaxes, Humbugs and Spectacles* (New York: Villard Books, 1990).
11. Georges Poulet, "Criticism and the Experience of Inferiority," *The Structuralist Controversy*, ed. Richard Macksey and Eugenia Donato (Baltimore: Johns Hopkins University Press, 1972), 59.
12. Donald Kuspit, "Chris Burden: The Feel of Power," *Chris Burden: A Twenty Year Survey* (Newport Harbor, CA: Newport Harbor Art Museum, 1988), 37.
13. George Maciunas, "Fluxus Art-Amusement," repr. in *Fluxus Etc.: The Gilbert and Lila Silverman Collection*, ed. Jon Hendricks (Bloomfield Hills, MI: Cranbrook Academy of Art Museum, 1981), 9.
14. Paul Schimmel, "Pay Attention," *Bruce Nauman*, ed. Joan Simon (Minneapolis: Walker Art Center and D.A.P., 1994), 72.
15. Zijderveld, 6.
16. Ibid, 162.

Grand
Schemes

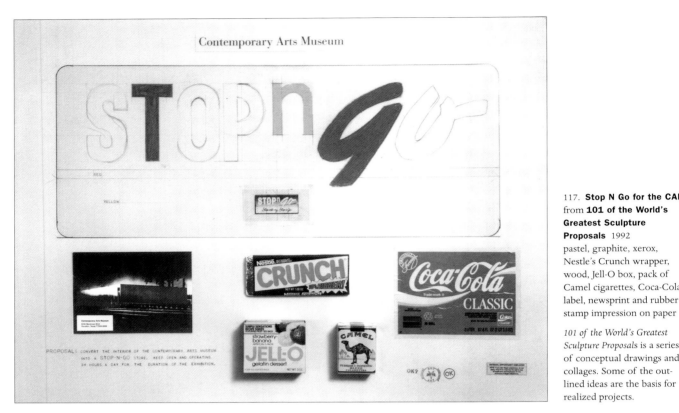

117. **Stop N Go for the CAM** from **101 of the World's Greatest Sculpture Proposals** 1992
pastel, graphite, xerox, Nestle's Crunch wrapper, wood, Jell-O box, pack of Camel cigarettes, Coca-Cola label, newsprint and rubber stamp impression on paper

101 of the World's Greatest Sculpture Proposals is a series of conceptual drawings and collages. Some of the outlined ideas are the basis for realized projects.

previous page:
Driving Two Cars (from Houston to Galveston)
detail, 1990 *(see pls. 125–128)*

118. **Knuckleheads** from **101 of the World's Greatest Sculpture Proposals** 1991
magazine cutout, googly eyes, glitter, pastel, graphite, colored pencil, toy plastic arms and rubber stamp impression on paper
Collection Marvin and Liz Seline, Houston

119. **The Big Sneeze** from **101 of the World's Greatest Sculpture Proposals** detail, 1991 *(see pl. 117)*
spray paint, charcoal, graphite, pastel, magazine cutouts, Kleenex and rubber cement on paper
The Barrett Collection, Dallas

right:
120. **The Big Sneeze** 1995
Art Guys studio
chicken wire, window screening, expanding foam sealant, polyurethane, acrylic, metal tank, pump, tubing, antifreeze, water, food coloring, sound chip and computer

Enormous nose intermittently emits sneezing sounds while spraying viscous colored liquid from nostrils.

121–122. **99 Bottles of Beer on the Wall** detail, 1993
Art Guys studio
99 unopened bottles of beer on wooden shelf
inset: full view

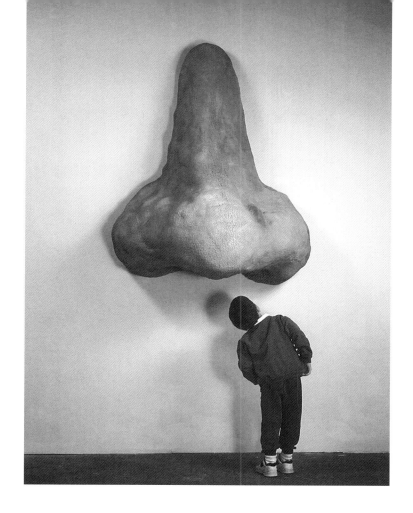

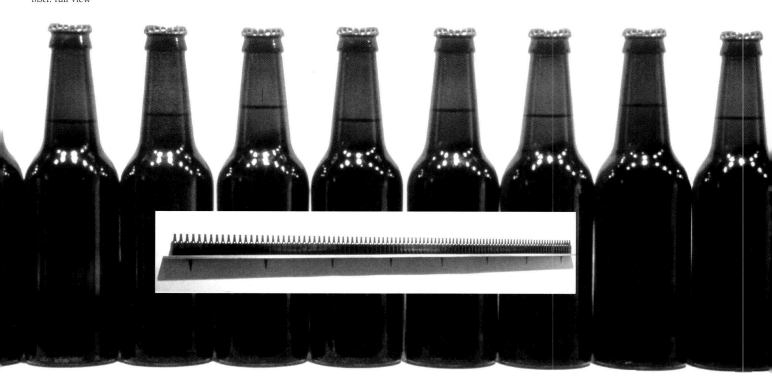

123–124. **The World of Wood**
above and detail, *left*, 1991
white pine, yellow pine, bass, oak, cedar, plywood and redwood
The Museum of Fine Arts, Houston; Museum purchase with funds provided by an anonymous donor

Objects whittled by the Art Guys one afternoon while sitting on the steps of the Harris County Courthouse, Houston.

125–128. **Driving Two Cars (from Houston to Galveston)** 1990
left: Art Guys studio
below: various locations
A single driver drives two cars 61 miles: the driver (Jack) drives first car a distance, runs back to retrieve second car, drives second car a distance past first car, runs back to retrieve first car, and so on. The rider (Mike) coaches driver and stays behind in the waiting car.
Note: Near halfway point, driver sprained ankle and rider had to help run and drive cars.
Duration: 26 hours over two days.

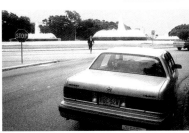

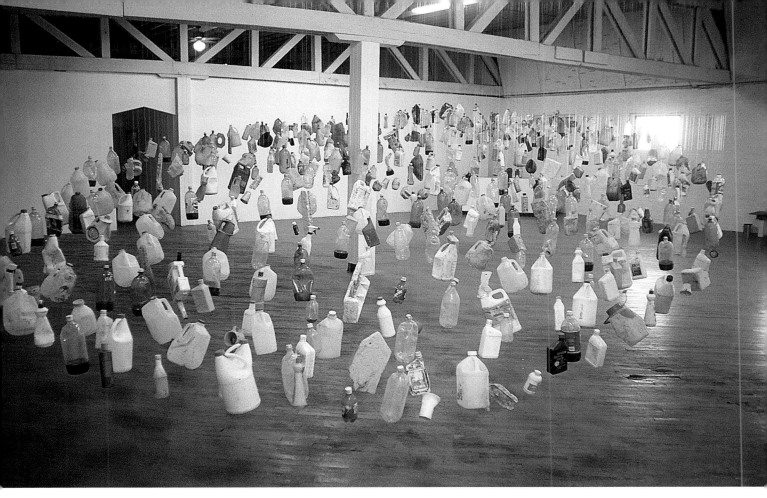

129. **Plastic Ellipse** 1991
Gallery 3, Huntington, West Virginia
plastic refuse and monofilament

Refuse collected from the Ohio River
and suspended to create a giant ellipse.

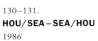

130–131.
HOU/SEA – SEA/HOU
1986
Puget Sound, Washington
glass, silicone, wooden
crate and one cubic foot
of water, each, from the
Gulf of Mexico and
Puget Sound

Water transported from
the Gulf of Mexico was
emptied into the Puget
Sound and vice versa.

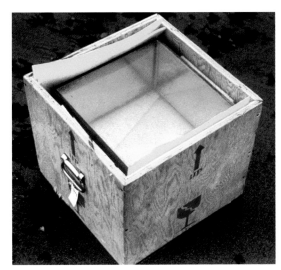

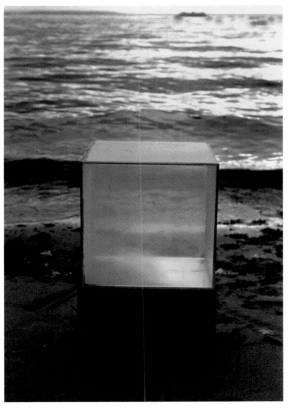

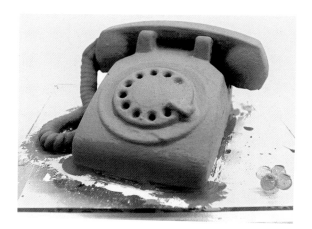

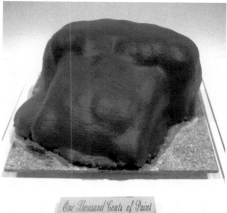

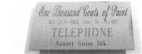

134–135. **1,000 Coats of Paint: Telephone** 1990–91
telephone, 1,000 coats of latex paint, glass and brass plaque
Collection Jesse Gregg and Jill Bedgood, Austin
left: in progress; *right:* finished state

opposite, background:
132. **1,000 Coats of Paint** (in progress, studio view) 1990
In a seven-month project, 1,000 separate coats of variously
colored paint were applied to 12 objects (baseball, two-by-four,
computer keyboard, telephone, teddy bear, paintbrush,
hammer, book, wooden stick, pair of eyeglasses, baseball glove,
toothbrush). The finished products were mounted on glass.
A complete color chart *(opposite, inset)* documents each
successive coat.

opposite, inset:
133. **1,000 Coats of Paint: Chart and Brushes** 1990–91
latex paint and graphite on paper with paintbrushes and
paint can opener
Collection Kristie Graham, Tucson

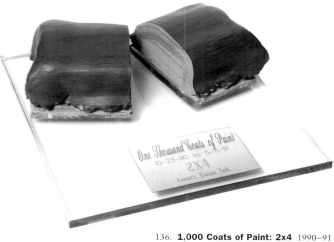

136. **1,000 Coats of Paint: 2x4** 1990–91
bisected wooden two-by-four, 1,000 coats
of latex paint, glass and brass plaque
Collection the artists

below:
137–138. **1,000 Coats of Paint: Teddy Bear** 1990–91
teddy bear, 1,000 coats of latex paint, glass and brass plaque
Collection Nancy Reddin Kienholz, Hope, Idaho
left: underside in progress; *right:* finished state

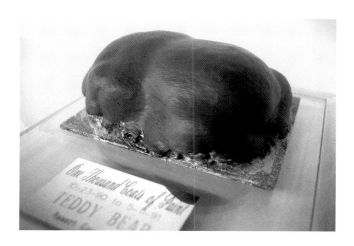

139. **Borrowed Pens: 1/1/93–1/1/94** 1993–94
pens, glass, silicone and brass plaque

140. **Appropriation #9, Peter Marzio 11/12/92, 10:39 am** 1992–94
coffee mug, black velvet and brass plaque in wood and glass vitrine
Collection Toni and Jeffery Beauchamp, Houston

Marzio is director of The Museum of Fine Arts, Houston.
The *Appropriations* series involved surreptitiously appropriating objects
from various museum directors, gallery owners, patrons and artists, then
exhibiting the collection of objects.

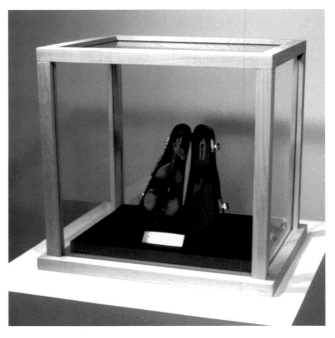

141. **Appropriation #10, Walter Hopps and Caroline Huber 7/28/93,
7:15 pm** 1993–94
miniature cello and case, black velvet and brass plaque in wood
and glass vitrine
Collection Toni and Jeffery Beauchamp, Houston

Hopps is founding director of The Menil Collection; Huber is former
co-director of DiverseWorks.

Structural
Integrity

142. **Ty Nant Sphere** 1993
Ty Nant water bottles and silicone
Collection Lynn Goode and
Tim Crowley, Houston

previous page:
Bonded Activity #4 detail, 1991
(see pl. 153)
pencils and glue; graphite on paper
Collection Carl and Rose Cullivan
Hock, Houston

Pencil sculpture drawing in progress.

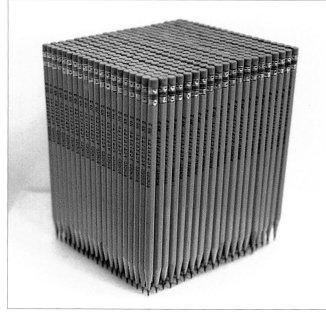

143. **Dawn** 1993
generic aspirin and glue

left:
144. **Pencil Bundle** 1989 *(see pl. 153)*
pencils and glue
Collection Baraka Sele, San Francisco

opposite, left to right:
145. **Shiner Bock Sphere** 1992
Shiner Bock beer bottles and silicone

Corona Tower 1992
Corona beer bottles and silicone

Clearly Canadian Sphere 1993
Clearly Canadian water bottles and
silicone
Collection Marvin and Liz Seline,
Houston

Rolling Rock Nub 1993
Rolling Rock beer bottles and
silicone

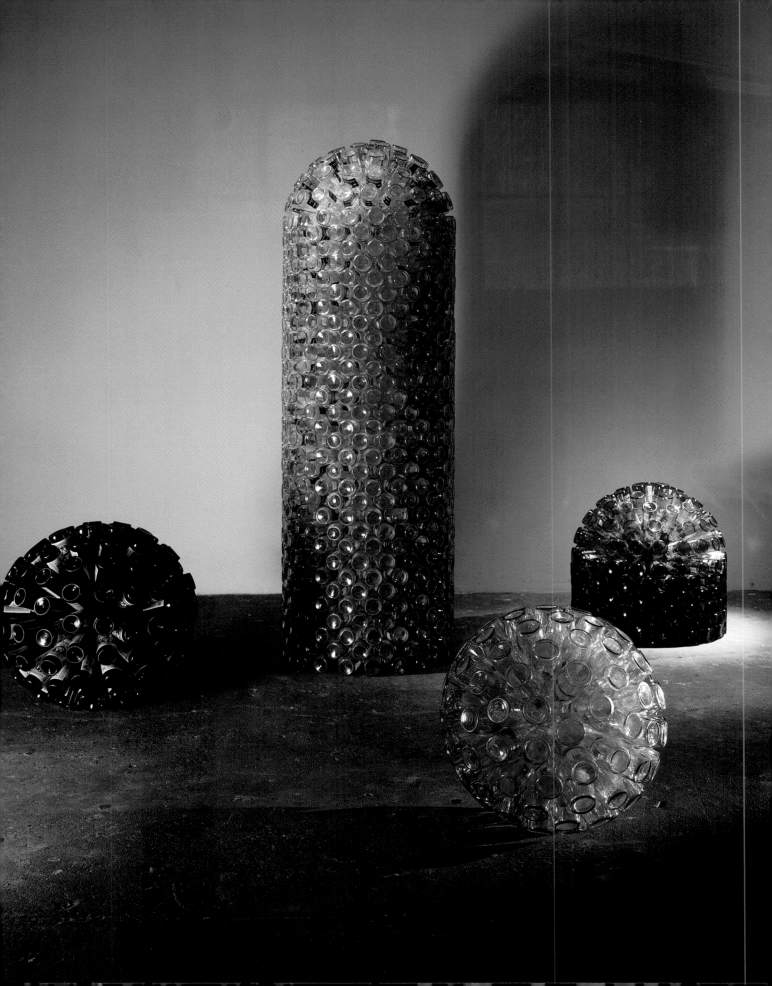

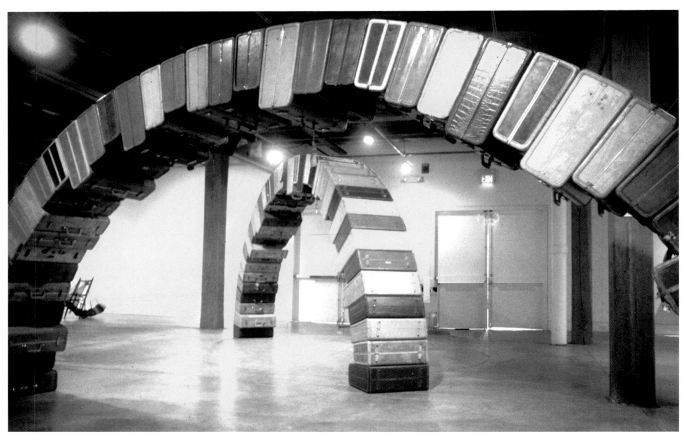

146. **Suitcase Arches** 1990
Contemporary Arts Center, New Orleans
suitcases, bolts and glue

147. **Suitcase Tower**
from **101 of the World's Greatest Sculpture Proposals** 1991 *(see pl. 117)*
graphite, pastel, ink, charcoal, spray paint and magazine cutouts on paper
Collection Mr. and Mrs. Michael Goldberg, Dallas

left and opposite:
148–149. **Suitcase Tower Maquette** 1995
pine, paint, graphite, U-shaped nails, plywood and glue
left: exterior; *opposite:* photomontage of interior

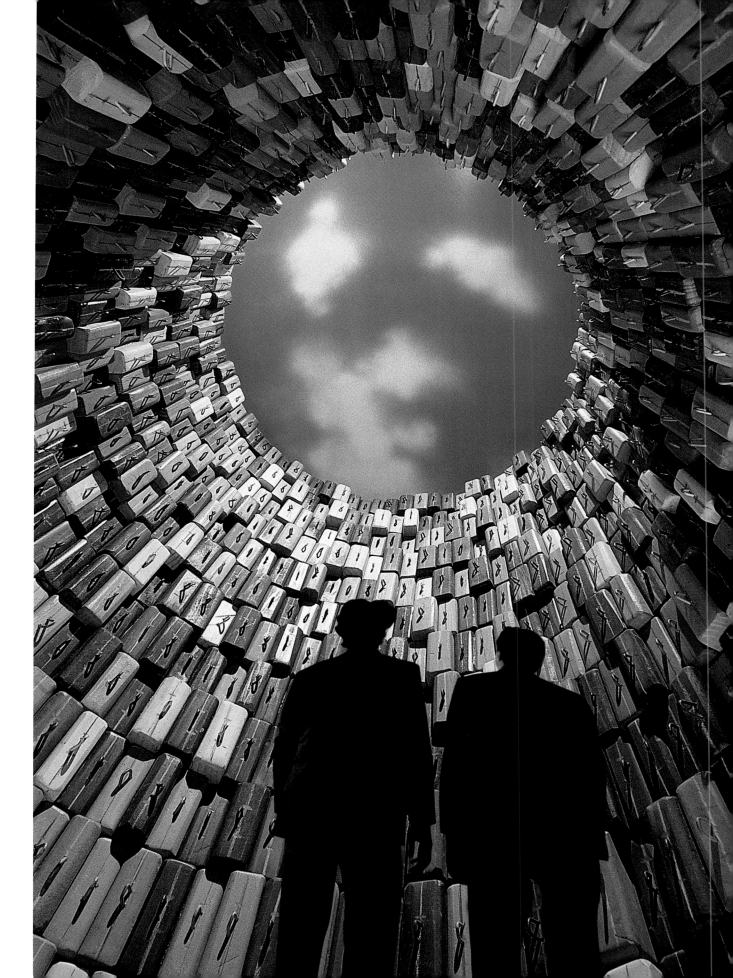

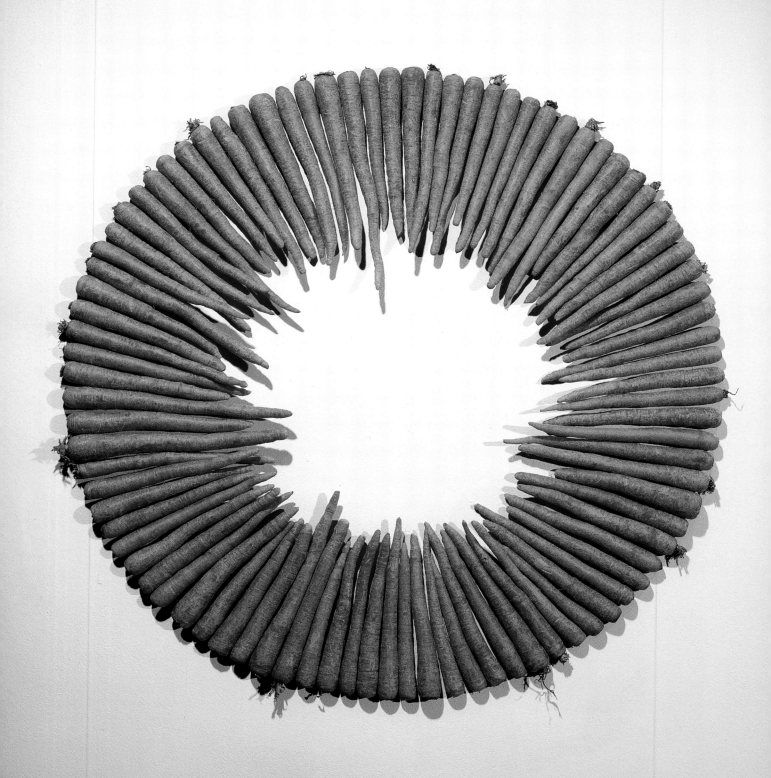

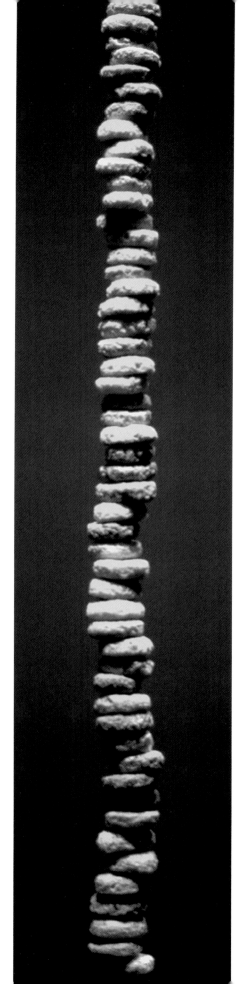

opposite:
150. **Carrot Wheel** 1995
(first installation 1993)
Art Guys Studio
carrots and nails

right:
151. **Fruit Loops Column** 1993
UAA Gallery, Anchorage, Alaska
Fruit Loops cereal stacked by a secret
technique

far right:
152. **Penny Column** 1992
(first installation)
Art Guys studio
pennies stacked by a secret technique

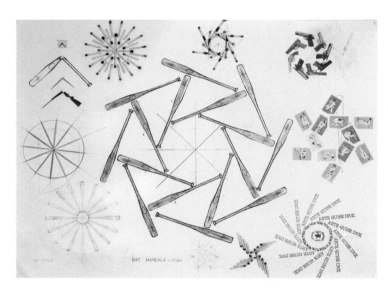

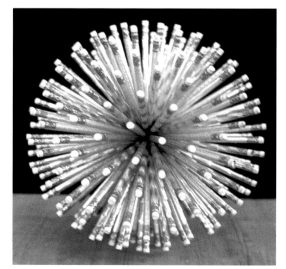

top to bottom:

153. **Bonded Activity #2** 1991
pencils and glue
Collection Rusty and Deedie Rose, Dallas

Bonded Activity is a series of works exploring the structural and architectural potential of pencils. The series title was taken from a brand name used by the J.R. Moon Pencil Co.

154. **Bat Mandala Study**
from **101 of the World's Greatest Sculpture Proposals** 1990 *(see pl. 117)*
pastel, graphite, paper matches, toothpicks, newsprint cutouts and rubber stamp impression on paper
Collection Chris McIntosh, Houston

155. **Bonded Activity #53 (Pretty Lady)** 1993
pencils and glue
Collection June and Oliver Mattingly, Dallas

Listen birds
These signs cost money
So rest awhile
But don't get funny.

Train approaches
Whistle screaming
Pause . . . avoid
That run-down feeling.[1]

It turns out that these two examples of commercial road-side poetry from mid century helped prepare me for encountering the Art Guys in Houston in 1983 (soon after they began collaborating). Via the Dada adventure and the Fluxus movement but not excluding the wisdom of highway advertising gimmicks (figs. 23–26), one takes one's cultural antecedents where one finds them.

The Art Guys' art exemplifies two things uncommon in the course of American art (and modern art generally). The first is the teaming of two unrelated artists who are sustaining a joint working career. Most such associations involve more intimate relationships with spouses or other family members such as brothers. Renowned modern art collaborators include the spouses Sonia and Robert Delaunay and the brothers Naum Gabo and Antoine Pevsner. The contemporary art arena encompasses such examples as the French husband and wife team of Anne and Patrick Poirier and the rather screwball Canadian collective General Idea.

From another creative realm, the Art Guys' collaboration reminds me of the American inventors Orville and Wilbur Wright. Like the Wright brothers, the Art Guys have doggedly pursued ostensibly divergent goals of idealism and pragmatism. As they undertake these quests, their working habits yield a free-flowing plurality of ideas while they adopt a practical approach to execution that tailors each task to one or the other's skills. The concomitant works exhibit a seamless facture blending the notions and aptitudes of both individuals.

The second uncommon quality of Art Guys art is its conspicuous humorousness. Accessible or obvious humor has not often been built into the essential workings of the visual arts. Instead, in the last two hundred years it has been American literature that appreciated and utilized both folk and contemporary vernacular humor. Clearly, from Mark Twain

The Next-to-Last Word

WALTER HOPPS

(and before) to T.S. Eliot (and beyond), puns, jokes, satire and irony have been crucial devices.

In the visual arts, the comic use of popular reference is less widespread, but historical examples of humor put to lofty purpose certainly exist. The Dadaists created humorous contrivances and ludicrous performances. Marcel Duchamp invoked bawdiness in his infamous *L.H.O.O.Q.* (1919, the *Mona Lisa* with a drawn-on mustache and goatee) and his *Fountain* (1917, an ordinary lavatory urinal signed as a "readymade" work of art). Paul Klee, Max Ernst and Kurt Schwitters developed refined yet often absurd images. Sexual and scatological comedy occurs in the abstract works of Francis Picabia and Joan Miro.

More recently, Pop artists have invoked humor in their elevation of commonplace and vulgar imagery. Claes Oldenburg, an artist whose work relates to the Art Guys, provoked laughter by utilizing vast dislocations of scale and pointedly inappropriate materials. Within the ongoing postmodern movement, irony is often so self-consciously invoked as to become the central concern. For example, Haim Steinbach's *Security and Serenity* (1985) respectfully displays toilet bowl brushes and Gem Lites (similar to lava lamps). The Art Guys have both thrived on this modus operandi of refined presentation and poked fun at it, as in the work entitled *When in Doubt, Use a Gold Plaque* (1988).

All these historical precedents have been bound by a central strategy of freely mixing high and low cultural references. The Art Guys most certainly have tapped into this vein. As one scans examples of their work, variations on humorous devices crop up everywhere: *Travel Logs* (1988, pl. 91) with its obvious pun, the double entendre of the *Go Tee Off* (1989, pls. 34–36) objects; *The Definition of Metaphysics . . .* (1990, pl. 90) and its overblown absurdity; the wretched excess of *Bubble Gum Chair* (1990, pl. 97), etc.

Two other imperatives of twentieth-century art are the use of innovative techniques or technologies and a self-conscious evidencing of process visible in the final form. Almost invariably the Art Guys' work either celebrates the "making" nature of the creative process (its steps and mechanics) or fondly parodies the process by producing artifacts that mix trivial means with excessive diligence or sincerity.

During the 13 years of their collaboration, the Art Guys, in their fashion, have surveyed a spectrum of modernist techniques and aesthetic concerns. This first comprehensive exhibition and catalogue easily reveal the degree to which the Art Guys team has been involved in a kind of *antic* art historical reflection.

Think Twice: Power and Price [2]

The first important aesthetic decision the Art Guys made was to identify themselves as a performance art team. Performance activity quickly evolved to become object-making. Keenly aware that all art involves making something out of nothing, they established their studio—in fact, their entire living milieu—as a practical base for accomplishing just that.

They have made beautiful forms out of common objects ordinarily destined to be thrown away. They have cultivated an appreciation of folk craft and naive art. They have taken clichés or popular sayings and objectified them as literal interpretations in drawings or three-dimensional objects. Twisting an aesthetic truism such as "good painting," they have transformed ordinary objects (such as a hammer and a telephone) by burying them beneath "a thousand coats of paint." These carefully cultivated techniques have provided the Art Guys with a system by which the mundane is changed into the valuable. They consciously practice an everyday alchemy of turning nothing into something.

figs. 23–26 Roadside signs from **Labor Day Weekend Roadside Sale** 1991 *(see pl. 79)*

These processes of transformation have been open to public scrutiny, not only in the Art Guys' frequent performance works but especially at their home-based studio. An exhibition space for their own works as well as that of other artists (called the Museum of Fine Art Guise), the studio is also an ongoing performance space where the rituals of everyday art-making are enacted *on display*. Unlike the secluded ateliers of most artists, theirs allows any interested audience intimate access to whatever experiments are going on. Neither a remote nor an arcane laboratory, their studio revolves around their professional, social and personal lives and is perhaps the most open of any I have encountered. An almost exhibitionist quality surrounds the Art Guys' process of creativity.

There are always patterns discernible within the oeuvres of artists that their creators don't consciously articulate. While most painters achieve chronological families of related work, conceptually oriented artists often develop in a less linear progression. In the Art Guys' work, themes and categories unfold, exist, expand and are resurrected over time. From 1983 to 1995, the Art Guys' body of work has included installations, performances, events, acts and trespasses, sculptures, objects, drawings and even the occasional painting that consists of more than 2,500 pieces. The internal returns in these investigations are what has prevented their disparate output from becoming, in one sense, just one damn thing after another.

NOTES
1. Two roadside signboard verses for Burma Shave shaving cream products, c. 1940.
2. Gasoline company slogan, c. 1960.

Musical
Composition

156. **Untitled #3 (Tree Music)** 1988
Sheet music tied to a tree; composition
complete when paper decays.

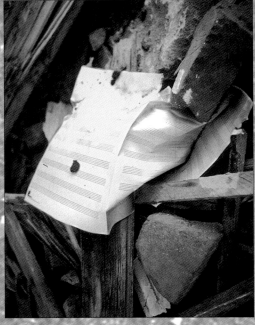

157. **Lot Music** 1988
Score composed at a demolition site by throwing
objects at sheet music.

previous page:
Pool Music 1988
University of Missouri, Kansas City
Generating musical scores by marking
locations of pool balls and cues during a
game of pool.

right and background:
158–159. **Untitled #7 (Lawnmower Music)** 1988
Score composed by shredding sheet music with
lawnmower.

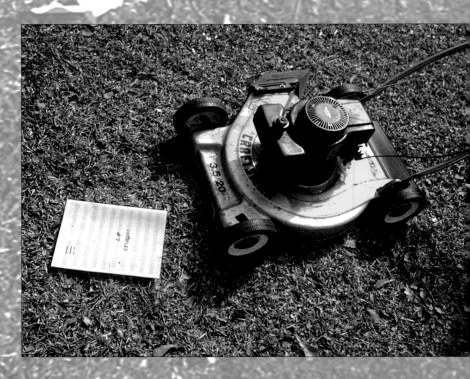

160. The Reflection of Sound, Resemblances To Light 1987
Lawndale Art and Performance Center, University of Houston
solar activated switches, computer, amplifier and speakers
Sunlight passing over solar switches activates computer-generated bird sounds.

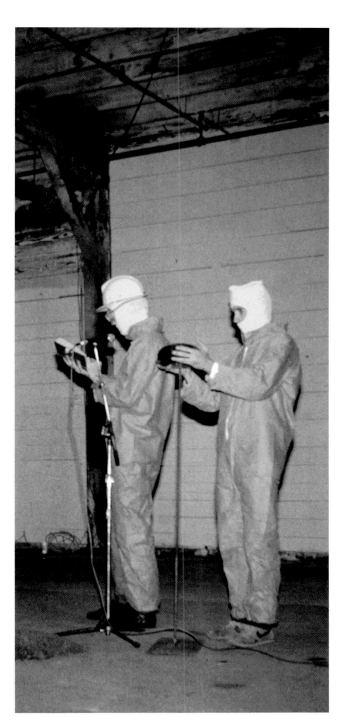

161. Spring Drop 1987
Commerce Street Warehouse, Houston
Percussive sound produced by dropping metal springs
of progressively larger sizes from the ceiling.

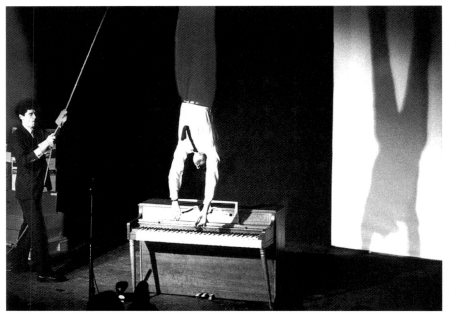

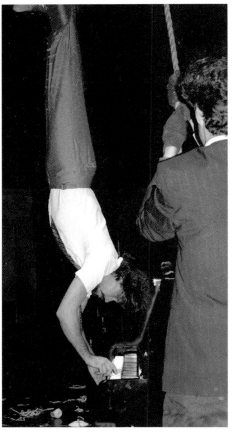

162–163. **Piano for Falling Man** (first performed 1986)
above: 1992, DiverseWorks, Houston
right: 1993, Marshall University, Huntington, West Virginia
Mike hoists Jack and, while suspended, Jack eats an apple and
plays an original composition entitled *Piano for Falling Man.*

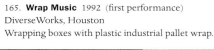

165. **Wrap Music** 1992 (first performance)
DiverseWorks, Houston
Wrapping boxes with plastic industrial pallet wrap.

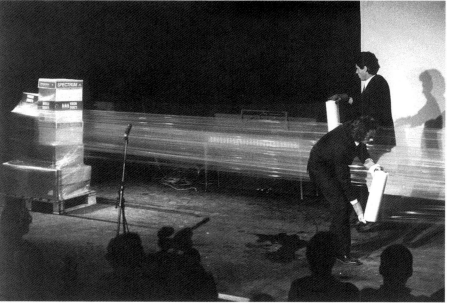

164. **Music for Sideburns** 1987
Lawndale Art and Performance Center,
University of Houston
Amplified sound of sideburns growing.

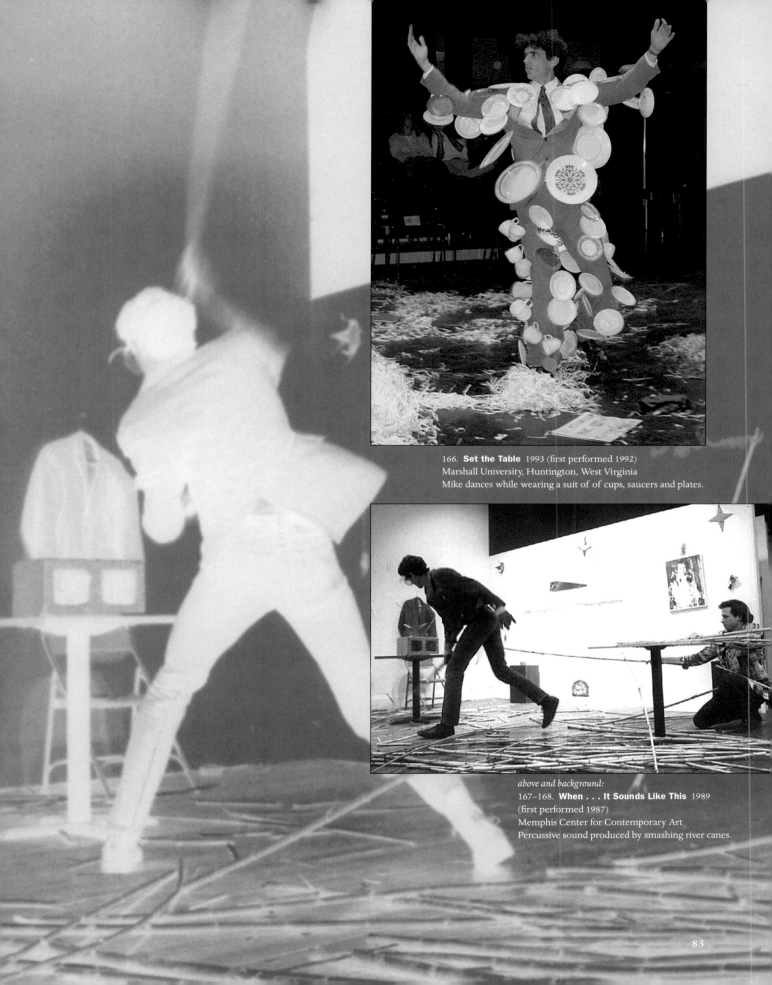

166. **Set the Table** 1993 (first performed 1992)
Marshall University, Huntington, West Virginia
Mike dances while wearing a suit of of cups, saucers and plates.

above and background:
167–168. **When . . . It Sounds Like This** 1989
(first performed 1987)
Memphis Center for Contemporary Art
Percussive sound produced by smashing river canes.

169. **Music for BB's** 1983
image from videotape,
3 min. 57 sec.

BB's poured into a glass
funnel.

170. **Music of the Spheres**
1986
image from videotape,
2 min. 40 sec.

Spherical objects of increasing size rolling down wires
of a piano.

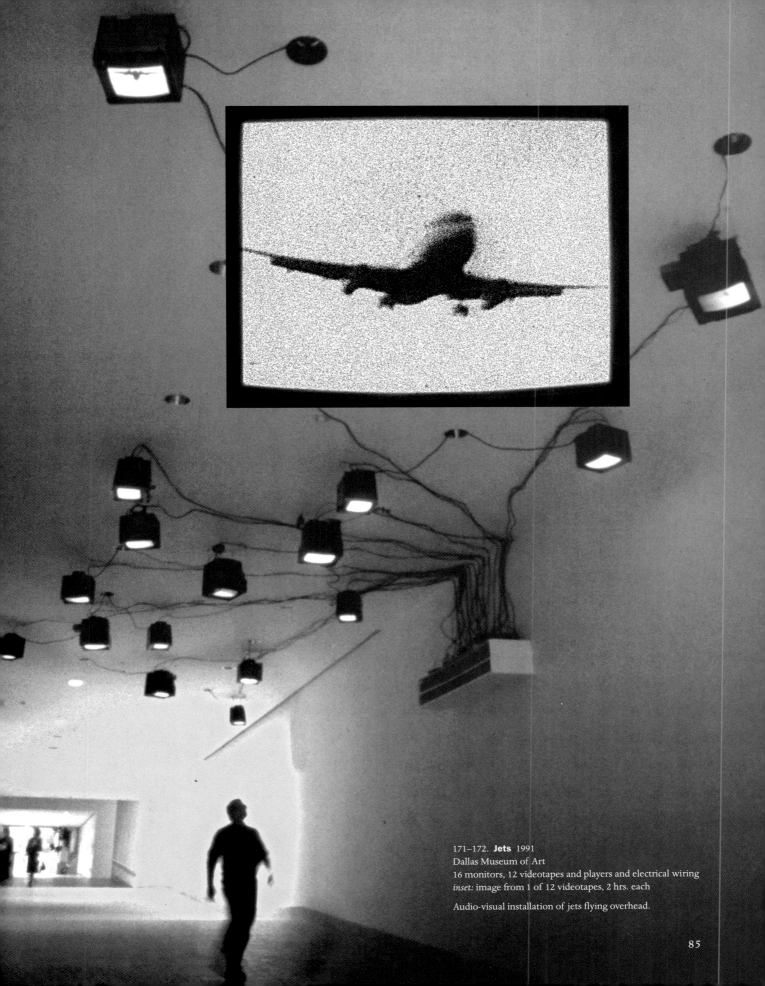

171–172. **Jets** 1991
Dallas Museum of Art
16 monitors, 12 videotapes and players and electrical wiring
inset: image from 1 of 12 videotapes, 2 hrs. each

Audio-visual installation of jets flying overhead.

Catalogue of the Exhibition

Height precedes width precedes depth. All works are courtesy the artists and Barry Whistler Gallery, Dallas, unless otherwise indicated.

Music for BB's 1983
video, 3 min. 57 sec. (pl. 169)

Rock Drop: Catastrophe Theory No. 6 1985
rock, marbles, silicone, glass and brass plaque
8 x 14 x 9 inches
Private Collection, Santa Fe (pl. 17)

Music of the Spheres 1986
video, 2 min. 40 sec. (pl. 170)

Art Guys Business Cards 1986–present
Art Guys business cards, card holder and wallet
2 x 3½ inches each (pl. 4)

Beat It, Burn It, and Drown It 1987
book, glass case and brass plaque
16 x 10 x 4½ inches
Collection David Brown, Houston (pls. 21–25)

Product Test #1: Suitcase Drag, Houston to San Antonio, Highway 90A, 234.7 Miles 1987
suitcase, Type C print and brass plaque
17 x 21 x 7 inches; 10¼ x 15¼ inches; 4 x 6 x ⅛ inches (pls. 28–31)

Lambchops for the Motor City 1987–88
Type C photographs, rubber stamps, ink pad, mirror, facial hair, videotape, musical score and brass plaques
variable dimensions

Suitcase in Space Project 1988
suitcase, gold foil, ceramic tile, globe, shaving kit, shirts, pants, socks, underwear, photographs, blueprint, NASA diagrams, monofilament and brass plaque
variable dimensions (pls. 26–27)

Travel Logs 1988
store-bought plastic-wrapped log with handle; wooden log with attached suitcase hardware, brass nails and leather handle
7 x 22 x 7 inches; 7½ x 18 x 7½ inches
Collection the artists (pl. 91)

When In Doubt, Use A Gold Plaque 1988
brass plaque on brass plate
10 x 8 x ¹⁄₃₂ inches
Collection Mrs. Patricia A. Galbreth, Nashville

Go Tee Off 1989
video, 31 min. 35 sec. (pls. 34–36)

Go Tee Off: Object #3 1989
enamel tin cup, golf club, wooden base, model maker's grass and brass plaque
39 x 11¼ x 11¼ inches
The Menil Collection, Houston

Suitcase Wheel
from **101 of the World's Greatest Sculpture Proposals** 1989
pencil, charcoal, ink, spray paint, pastel and suitcase tag on paper
25 x 32¾ x 1½ inches
Collection Carol Taylor, Dallas

Ashes of the American Flag Rearranged into Three Other Easily Recognizable Symbols 1990
ashes of three American flags and spray adhesive on paper
30 x 22½ x 1¼ inches each
Collection Ian Glennie, Houston (pls. 105–106)

Bat Mandala Study
from **101 of the World's Greatest Sculpture Proposals** 1990
pastel, graphite, paper matches, toothpicks, newsprint cutouts and rubber stamp impression on paper
25 x 32½ x 1¼ inches
Collection Chris McIntosh, Houston (pl. 154)

The Definition of Metaphysics by Gustave Flaubert from "Dictionnaire des idées reçues" or **The Boss Piece** 1990
suitcases, blinking colored light bulbs, house paint, wood shelves, metal shelf brackets and electrical wiring
98 x 130 x 9¼ inches (pl. 90)

Fuse Drawing 1990
burnt fuse marks on paper
25 x 32½ x 1½ inches
Private Collection, Houston

Match Grid #1 1990
matches and glue on paper
25 x 32¾ x 1½ inches
Collection Russell Duesterhoft, Houston

Smoke Bomb Drawing 1990
smoke bomb stain on paper
25 x 32½ x 1⅜ inches
Collection Linda Bednar, Houston

You Get What You Pay For 1990
framer's receipt and frame
14½ x 17 x 1¼ inches
Collection Bill and SueSue Bounds, Atlanta (pl. 83)

1,000 Coats of Paint: Chart and Brushes 1990–91
latex paint and graphite on paper with paintbrushes and paint can opener
28¾ x 40½ x 2 inches
Collection Kristie Graham, Tucson (pl. 133)

1,000 Coats of Paint: 2x4 1990–91
bisected wooden two-by-four, 1,000 coats of latex paint, glass
and brass plaque
3³/₄ x 12 x 12¹/₂ inches
Collection the artists (pl. 136)

1,000 Coats of Paint: Paintbrush 1990–91
paintbrush, 1,000 coats of latex paint, glass and brass plaque
3 x 14 x 13¹/₂ inches
Collection Arman, New York

1,000 Coats of Paint: Teddy Bear 1990–91
teddy bear, 1,000 coats of latex paint, glass and brass plaque
4 x 12 x 13¹/₂ inches
Collection Nancy Reddin Kienholz, Hope, Idaho (pls. 137–138)

1,000 Coats of Paint: Telephone 1990–91
telephone, 1,000 coats of latex paint, glass and brass plaque
6¹/₂ x 14¹/₄ x 17¹/₄ inches
Collection Jesse Gregg and Jill Bedgood, Austin (pls. 134–135)

Anchovy Birdhouse 1990–91
fiberboard, maple dowel, dried anchovies and glue
9¹/₂ x 11 x 10¹³/₁₆ inches

Broken Reflective Glass Birdhouse 1990–91
fiberboard, maple dowel, and silicone with fragments of
tempered architectural glass (from Allied Bank Building after
Hurricane Alicia, Houston)
9¹/₂ x 11 x 10¹³/₁₆ inches
Collection Elizabeth Aston, Houston (pl. 82)

Dustpan Birdhouse 1990–91
fiberboard, maple dowel and dustpan
9¹/₂ x 11 x 10¹³/₁₆ inches
Collection Caroline Huber and Walter Hopps, Houston (pl. 76)

Feathers Birdhouse 1990–91
fiberboard, maple dowel, pheasant feathers and glue
9¹/₂ x 11 x 10¹³/₁₆ inches
Collection Ed and Kathy Wilson, Houston

Galvanized Nails Birdhouse 1990–91
fiberboard, maple dowel, galvanized nails and glue
9¹/₂ x 11 x 10¹³/₁₆ inches
Collection John Roberson, Houston (pl. 80)

Wacky Birdhouse 1990–91
fiberboard and maple dowel with aluminum, copper and pewter
winged goddess, rubber, pack of Camel cigarettes, fiberglass,
plastic soldier, glue and much, much more
9¹/₂ x 11 x 10¹³/₁₆ inches
Collection Tom and Moira Lafaver, Houston

Bottom of the Third from **The Game** 1990–91
baseball bat, baseball and nails
42 x 7³/₄ x 4 inches; 7³/₄ (diameter) inches

Top of the Fourth from **The Game** 1990–91
baseball bat, baseball, pheasant feathers and glue
41 x 9 x 4 inches; 7 (diameter) inches

Bottom of the Fifth from **The Game** 1990–91
cast liquid rubber
38 x 2⁵/₈ (diameter) inches; 2³/₄ (diameter) inches (pl. 98)

Top of the Sixth from **The Game** 1990–91
cast bronze
38 x 2⁵/₈ (diameter) inches; 2³/₄ (diameter) inches
Private Collection, Santa Fe

Bottom of the Sixth from **The Game** 1990–91
baseball bat, baseball, copper nails and pennies
36 x 3¹/₂ x 3 inches; 3¹/₂ (diameter) inches
Collection Sonny Burt and Bob Butler, Dallas

Bottom of the Seventh from **The Game** 1990–91
pencils, glue and paper
35 x 2³/₄ x 2³/₄ inches; 2³/₄ (diameter) inches
Collection Kristie Graham, Tucson

101 of the World's Greatest Toothbrushes (More or Less) 1990–95
toothbrushes and a variety of materials
variable dimensions
Collections of Elizabeth Aston, Houston; Sonny Burt and Bob
Butler, Dallas; Trish Herrera, Houston; Carl and Rose Cullivan
Hock, Houston; Steve and Pat Lasher, Houston; Carson and
Molly Luhrs, Houston; Ken and Andrea Maunz, Kansas City,
Missouri; Sarah Shartle Meacham, Portland, Maine; Private Col-
lection, Houston; and Robert F. Smith, Houston. (pls. 65–75)

Bubble Gum Chair 1990–present
wooden chair and chewing gum on mirror-covered pedestal
41¹/₂ x 22 x 22 inches (pl. 97)

Suitcase Wheel 1990–95
suitcases and steel armature
200 x 200 x 21¹/₄ inches

The Big Sneeze
from **101 of the World's Greatest Sculpture Proposals** 1991
spray paint, charcoal, graphite, pastel, magazine cutouts, Kleenex
and rubber cement on paper
25 x 32⁵/₈ x 1³/₈ inches
The Barrett Collection, Dallas (pl. 119)

Bonded Activity #2 with drawing 1991
spherical object: pencils and glue; drawing: graphite on paper
6³/₄ (diameter) inches; 25¹/₄ x 32³/₄ x 1¹/₂ inches
Collection Rusty and Deedie Rose, Dallas (pl. 153)

Bonded Activity #19 1991
pencils and glue
36 x 6 x 6 inches; 5¹/₂ x 10 x 4 inches
Collection John and Dede Brough, Arlington, Virginia (pl. 8)

Goatee Off: Manifest Destiny 1991
Buffalo Bill and Red Cloud U.S. postage stamps on paper
25 x 32 x 1³/₈ inches
Collection Louy Meacham, Houston (pl. 9)

Knuckleheads
from **101 of the World's Greatest Sculpture Proposals** 1991
magazine cutout, googly eyes, glitter, pastel, graphite, colored
pencil, toy plastic arms and rubber stamp impression on paper
22 x 30 x 1³/₈ inches
Collection Marvin and Liz Seline, Houston (pl. 118)

No Cash Value #1 1991
one dollar bills and glue on paper
25 x 32³/₈ x 1³/₈ inches

No Cash Value #2 1991
one dollar bills and glue on paper
25 x 32¹/₂ x 1³/₈ inches
Private Collection, Houston

Shot Room
from **101 of the World's Greatest Sculpture Proposals** 1991
magazine and encyclopedia cutouts, color pencil, graphite, char-
coal, ink, bullet hole decals and cardboard on paper
25 x 32¹/₄ x 1³/₈ inches
Collection Robert F. Smith, Houston

Suitcase Tower
from **101 of the World's Greatest Sculpture Proposals** 1991
graphite, pastel, ink, charcoal, spray paint and magazine cutouts
on paper
25 x 32¹/₂ x 1³/₈ inches
Collection Mr. and Mrs. Michael Goldberg, Dallas (pl. 147)

The World of Wood 1991
white pine, yellow pine, bass, oak, cedar, plywood and redwood
20 x 95 x 11 inches
The Museum of Fine Arts, Houston; Museum purchase with
funds provided by an anonymous donor (pls. 123–124)

Appropriation #1, Ed Wilson 6/9/91, 6:45pm 1991–94
sock, black velvet and brass plaque in wood and glass vitrine
13³/₄ x 14¹/₄ x 11¹/₄ inches

Appropriation #7, Barry Whistler 12/3/91, 8:35am 1991–94
Michael Tracy sculpture, black velvet and brass plaque in wood
and glass vitrine
13³/₄ x 14¹/₄ x 11¹/₄ inches

Appropriation #8, Suzanne Delehanty 5/28/92, 6:51pm
1992–94
Neuberger Museum pin, black velvet and brass plaque in wood
and glass vitrine
13³/₄ x 14¹/₄ x 11¹/₄ inches
Collection Toni and Jeffery Beauchamp, Houston

Appropriation #9 Peter Marzio 11/12/92, 10:39am 1992–94
coffee mug, black velvet and brass plaque in wood and glass vitrine
13³/₄ x 14¹/₄ x 11¹/₄ inches
Collection Toni and Jeffery Beauchamp, Houston (pl. 140)

Bonded Activity #45 with drawing 1992
pencils, glue, Dutch wooden shoe; and graphite on paper
5 x 11 x 4¹/₂ inches; 25 x 32¹/₂ x 1¹/₂ inches

Coca Cola Sphere 1992
Coca Cola bottles and silicone
20 (diameter) inches
Collection Sonny Burt and Bob Butler, Dallas

Corona Tower 1992
Corona beer bottles and silicone
80¹/₂ x 25 inches (pl. 145)

Penny Column 1992
pennies stacked by a secret technique
240 x ³/₄ x ³/₄ inches (pl. 152)

Remove the Meander of Buffalo Bayou (Make It Straight)
from **101 of the World's Greatest Sculpture Proposals** 1992
map, graphite, cellophane tape and rubber stamp impression
on paper
25 x 32¹/₂ x 1³/₈ inches
Collection Robert F. Smith, Houston

Stop N Go for the CAM
from **101 of the World's Greatest Sculpture Proposals** 1992
pastel, graphite, xerox, Nestle's Crunch wrapper, wood, Jell-O
box, pack of Camel cigarettes, Coca-Cola label, newsprint and
rubber stamp impression on paper
27⁷/₈ x 32⁷/₈ x 1⁷/₈ inches (pl. 117)

Two or More Tools Should Be Combined Whenever Possible 1992
bowling ball and push broom; hammer and pencil; and graphite,
pastel, charcoal, rubber stamp impression, book page and
a pencil on paper
25 x 32 inches; 9 x 17 x 16 inches; 5 x 22 x 1¹/₂ inches
Collection Gary J. Somberg, Houston

Pennies from Heaven 1992–present
pennies with "Art Guys" stamped into them
³/₄ (diameter) ¹/₁₆ inches (pl. 84)

Bonded Activity #47 with drawing 1993
pencils and glue; graphite on paper
25 x 32 x 1³/₈ inches; 7 (diameter) inches each
Collection Marshal and Victoria Lightman, Houston

Bonded Activity #49 and #50 1993
pencils and glue
8 x 28 x 8 inches each

Bonded Activity #53 (Pretty Lady) 1993
pencils and glue
15 (diameter) inches
Collection June and Oliver Mattingly, Dallas (pl. 155)

Chastity 1993
suitcase and electromechanical parts
12 x 19 x 8 inches
Collection Michael Caddell and Tracey Conwell, Houston (pl. 94)

Flea Circus 1993
fleas and glue on paper
25 3/8 x 32 7/8 x 1 3/8 inches

Three Ideas and a Joke
from **101 of the World's Greatest Sculpture Proposals** 1993
magazine cutouts, playing cards, spray paint, colored pencil,
graphite, fake beer joke box, googly eyes, xerox, plastic mermaid
and rubber stamp impression on paper
24 7/8 x 32 7/8 x 1 5/16 inches

Topo Chico Tower 1993
Topo Chico beer bottles and silicone
46 3/4 x 23 1/2 x 23 1/2 inches

Ty Nant Sphere 1993
Ty Nant water bottles and silicone
22 1/4 (diameter) inches
Collection Lynn Goode and Tim Crowley, Houston (pl. 142)

**Appropriation #10, Walter Hopps and Caroline Huber
7/28/93, 7:15pm** 1993–94
miniature cello and case, black velvet and brass plaque in wood
and glass vitrine
13 3/4 x 14 1/4 x 11 1/4 inches
Collection Toni and Jeffery Beauchamp, Houston (pl. 141)

Aunt Bea 1994
ants, bees and glue on paper
25 1/2 x 33 x 1 3/8 inches (pl. 87)

Carrot Wheel
from **101 of the World's Greatest Sculpture Proposals** 1994
color xerox, pastel, graphite, charcoal, newsprint, black-and-
white photograph and glue on paper
25 3/8 x 32 7/8 x 1 3/8 inches

Cigarette Drawing 1994
cigarette filters and stains on paper
25 3/8 x 32 7/8 x 1 3/8 inches

Floating 1994
butterfly wings and glue on paper
25 1/4 x 32 7/8 x 1 1/4 inches (pl. 86)

The United States of America 1994
one dollar bills and glue on paper
25 3/8 x 32 7/8 inches
Collection Steve and Pat Lasher, Houston (pl. 85)

Bulk Up for CAM 1994–95
silver gelatin prints and performance at LaBare
"before" photographs: 11 x 13 x 3/4 inches each;
"after" photographs: 72 1/2 x 39 x 1 3/8 inches each (pls. 57–60)

Art Guys Action Figures 1995
plastic, plumber's putty, wood, glue, straight pins and paint on
wooden platforms under glass domes; fabricated by Joe W. Porter
13 1/4 x 9 1/2 (diameter) inches (pl. 64)

The Big Sneeze 1995
chicken wire, window screening, expanding foam sealant,
polyurethane, acrylic, metal tank, pump, tubing, antifreeze,
water, food coloring, sound chip and computer
69 x 52 x 26 inches (pl. 120)

Excuse Me, I Dropped My Hammer 1995
hammer, motor, wood, mechanical parts, wire, stanchions,
rayon fringe and satin
240 x 31 x 31 1/2 inches (page 1)

Googly Eyes: Idea No. 17
from **101 of the World's Greatest Ideas
for the Contemporary Arts Museum** 1994–95
plastic, motor, paint, sealant and electrical wiring
60 x 60 x 12 inches each

Gorilla Art 1995
a temporary intervention: ivy-covered topiary monkeys attached
to *Manilla Palm* (1978, permanent installation, west lawn, CAM)
by Mel Chin

Match Installation #12: Change 1995
wooden matches and cannon fuse
120 x 240 x 2 1/2 inches

On Guard 1995
assorted costumes and paraphernalia for the exhibition
security guards
variable dimensions

Private Eyes: Barry of Dallas 1995
oil on board; and acrylic on canvas with electrical wiring,
light bulbs, metal rod, wood and plastic milk crate
42 x 35 x 2 1/2 inches; 97 1/2 x 59 1/2 x 46 inches

Suitcase Tower Maquette 1995
pine, paint, graphite, U-shaped nails, plywood and glue
47 x 47 1/2 x 33 inches (pls. 148–149)

Working Art Guys 1995
chicken wire, expanding foam sealant, paint, clothes, tools,
motor, wood and wire
life size: 6 foot 4 9/16 inches and 5 foot 11 inches (pl. 63)

Biography

Michael Galbreth

Michael Galbreth was born January 6, 1956, in Philadelphia, Pennsylvania, to William and Patricia Galbreth, the second of their five children. The family lived in Charlotte, North Carolina, and Houston, but most of Galbreth's early childhood was spent in Asheville, North Carolina, followed by middle and high school years in Nashville, Tennessee.

As a child, Galbreth mowed neighborhood lawns, sacked groceries and delivered newspapers. He was always good at drawing, and in the second grade he won a coloring prize, a statue of the Virgin Mary. This was a considerable triumph for Galbreth and the other boys in the class because no boy had ever won the prize before. Galbreth's mother was a champion salesperson at a department store and his father, a former air force pilot, worked for a home loan company.

During high school, Galbreth aspired to be a writer and had a particular interest in William Faulkner and Eugene Ionesco's *Rhinoceros*. He was a member of the Mighty Irish Art Players, a group that performed humorous skits before football pep rallies. During senior year, his French class took a ten-day trip to Paris where Galbreth was impressed by visits to the Louvre, the Jeu de Pomme and Versailles.

Galbreth studied art and creative writing at Middle Tennessee State University in Murfreesboro from 1974 to 1976 . He then took off two years, working in warehouses and airports before traveling again to Europe to visit the museums. Galbreth received a Bachelor of Fine Arts degree from Memphis State University in 1980. There he studied with Bill Dunlap and Ken Gray and met James Surls, a visiting professor of sculpture from the University of Houston who suggested he apply to the University of Houston for graduate work.

Galbreth enrolled at the University of Houston in the fall of 1981. In 1982 he married Lynn Franzen (they divorced in 1989). Galbreth met Jack Massing at an exhibition at Lawndale, an art and performance center then affiliated with the University of Houston, in the spring of 1982. Galbreth received a Masters of Fine Arts degree from the University of Houston in 1984.

Jack Massing

Jack Massing was born on January 4, 1959, in Buffalo, New York, to Paul and Maureen Massing, the fourth of their five children. Paul was a chemical engineer at Union Carbide, and Massing spent his childhood in Tonawanda, a town eight miles west of Buffalo.

As a child, Massing had a paper route, mowed lawns, shoveled snow and set up Kool-Aid stands. An accomplished artist himself, Massing's father encouraged his children to paint and draw. He also presented science shows on their driveway for the kids in the neighborhood; he would explore such ideas as heating and cooling by dipping objects (a rose, a hot dog and a rubber ball) into liquid nitrogen and then letting the objects fall onto the driveway and shatter. The Massing driveway also served as a kind of drive-in cinema for the neighborhood with slide shows of family vacations and fishing trips complete with chairs and popcorn.

In high school, Massing aspired to be a biologist or a forester. He played ice hockey and did some drawing and painting. His jobs during high school included delivering pizza, dishwashing at a Denny's Restaurant and serving as a butcher's apprentice for two years.

From 1977 to 1979, Massing attended Niagara County Community College in Niagara Falls, where he received Associate of Science and Associate of Arts degrees. While in college he worked at Artpark in Lewiston, New York, a state park with a seminal public art program. There he met and assisted several artists-in-residence including Pat Oleszko, Buster Simpson, Andrew Leicester, Bob Wade, Suzanne Harris, Story Mann and James Benning.

After working on the assembly line of a Chevrolet plant during the summer of 1979, Massing moved to New York to assist Oleszko with a performance work for the 1980 Winter Olympics in Lake Placid. He later moved to Seattle to work for Buster Simpson, building sculpture and furniture and learning to blow glass.

Massing helped his parents move to Houston in 1980 and attended the Glassell School of Art at The Museum of Fine Arts, Houston, the next year. He met Michael Galbreth at an exhibition at Lawndale in the spring of 1982. James Surls, a professor of sculpture at the University of Houston, had included one of Massing's works in the exhibition and encouraged Massing to finish his undergraduate degree at the University of Houston. Massing received his Bachelor of Fine Arts there in 1984.

fig. 27 **Ouija Speaks the Truth** 1990
altered Ouija board

fig. 28 **Art Guys Signature Stamp** 1989–present
rubber stamp impression and ink

Solo Exhibitions

1983

gmaalsbsrientgh. Studio One, Houston. Sept. 22, noon to midnight.

1985

Particles. Midtown Art Center, Houston. Oct. 26–Dec. 14.

Michael Galbreth, Jack Massing. Hiram Butler Gallery, Houston. Nov. 21–Dec. 12.

1986

Mustaches for Seattle: Sea/Hou–Hou/Sea. 911 Contemporary Arts Center, Seattle. Sept. 4–27.

1989

don't get left behind get right behind. San Jacinto College, Houston. opened Feb. 17.

Talking Pictures: The Art Guise at Full Tilt. Sonic Arts Gallery, San Diego. May 5–June 3.

1990

Art Guys. Barry Whistler Gallery, Dallas. March 30–April 25.

1991

Art Guys. Gallery 3, Huntington, West Virginia. March 7–April 20.

AAArt Guys. Barry Whistler Gallery, Dallas. May 24–June 22.

Jets (video installation). Dallas Museum of Art, Dallas. Nov. 12–Dec. 2.

1992

Group Show. Zero One Gallery, Los Angeles. Nov. 7–Dec. 3.

1993

Art Guise. Janie Beggs Gallery, Aspen. opened March 27.

Those Art Guys Again. Barry Whistler Gallery, Dallas. April 23–May 29.

Something from Nothing. UAA Gallery, University of Alaska at Anchorage. Nov. 11–Dec. 12.

1994

Good and Plenty. Lesikar Gallery, Houston. March 1–April 2.

Today's Special. El Palomar Restaurant, Houston. March 9–April 4. brochure.

1995

The Art Guys: Think Twice 1983–1995. Contemporary Arts Museum, Houston. April 8–June 25. catalogue essays by Lynn M. Herbert, Dave Hickey, Walter Hopps and David Levi Strauss.

Title to be announced. Capp Street Project, San Francisco. Sept. 7–Nov. 4. catalogue.

Selected Group Exhibitions

1986

Collaborators: Artists Working Together in Houston, 1969-86. Glassell School of Art, The Museum of Fine Arts, Houston. Sept. 18–Oct. 1. catalogue essay by Janet Landay.

1987

Sculpture: The Spectrum. Lawndale Art and Performance Center, University of Houston. May 9–June 20 (traveled to Blue Star Art Space, San Antonio, Oct. 31–Dec. 13). catalogue essays by Charmaine Locke and James Surls.

1988

Houston/Detroit Exchange. Michigan Gallery, Detroit. Jan.12–Feb. 6.

East End Show. Lawndale Art and Performance Center, University of Houston. juror: Richard Marshall. May 3–28.

Houston Area Exhibition. Sarah Campbell Blaffer Gallery, University of Houston. jurors: Alison de Lima Greene, Edward and Nancy Reddin Kienholz and Richard Koshalek. Sept. 9–Oct. 23. catalogue.

Space Alternative. Jesse H. Jones Public Library, Houston. Nov. 5–Jan. 2.

1989

Project Diomede. The Clocktower Gallery, organized by The Institute for Contemporary Art (P.S. 1 Museum), New York. May 18–July 2. brochure.

The Urban Preserve: Freeway as Art. Sewall Art Gallery, Rice University, Houston. Nov. 7–Dec. 20.

Messages from the South. Sewall Art Gallery, Rice University, Houston. Nov. 7–Dec. 20.

Not Just Idle Chatter. 78 N. Main, Memphis. opened Nov. 25.

1990

Photo Works: AAAArt Guize Ink, Cosgrove/Orman, John Runnels, Charlie Sartwell. Mother Dog Studios, Houston. Feb. 24–March 31.

Lost and Found: An Invitational Exhibit of Found Object Works. Edith Baker Gallery, Dallas. March 9–April 28.

LANDscapes: Outdoor Sculpture Competition. Buffalo Bayou Park, Houston. organized by DiverseWorks with the Houston International Festival. curated by James Surls, Rachel Hecker and Jim Edwards. March 30–May 15.

See Through Us: A Survey of Portraiture Under the Guise of Art. Treebeards Restaurant, Houston. June 9–July 9.

Meauxs Bayou Monumental Sculpture Coupe: Bastille Day Show and Celebration. 5223 Feagan, Houston. July 1.

Inside/Outside. Barry Whistler Gallery, Dallas. Nov. 30–Dec. 22.

1991

Texas Dialogues. Dallas•Houston•San Antonio. Blue Star Art Space, San Antonio. Feb. 1–March 17. brochure.

Texas Art Celebration '91. 1600 Smith in Cullen Center, Houston. organized by the Assistance League of Houston. juror: Becky Duval Reese. Feb. 14–May 7.

5th Anniversary Exhibition. Barry Whistler Gallery, Dallas. Feb. 22–March 30.

House. Laguna Gloria Art Museum, Austin. March 10–April 28.

Creative Partners. Sewall Art Gallery, Rice University, Houston. Aug. 20–Oct. 12. catalogue.

Contemporary Issues. DiverseWorks, Houston. Sept. 14–Oct. 2. catalogue.

Thrift Shop Show. Commerce Street Artists Warehouse, Houston. opened Oct. 5.

The Image of the Cross. Putti, Dallas. Oct. 26–Nov. 9.

1992

Houston Area Exhibition. Sarah Campbell Blaffer Gallery, University of Houston. jurors: Michelle Barnes, Patrick Murphy and Andres Serrano. Feb. 8–March 29. catalogue.

Erotic Art Show. Summer Street Studios, Houston. opened Feb. 15.

Buffalo Bayou Artpark Inaugural Exhibition. Buffalo Bayou Park, Houston. organized by the Union of Independent Artists with the Houston Parks and Recreation Department and the Municipal Arts Commission. opened Feb. 29.

re: Creation, Re-creation, Recreation. Laguna Gloria Art Museum, Austin. March 7–April 2. brochure.

Some of Houston's Known and Underknown, An Exhibition of Contemporary Sculpture. One Allen Center, Houston. organized by Sally Reynolds. July 30–Oct. 2.

FluxAttitudes. The New Museum of Contemporary Art, New York. Sept. 26–Jan. 3. catalogue.

Avenues of Departure: Twelve Houston Artists. Contemporary Arts Center, New Orleans. Dec. 5–Jan. 17. catalogue essay by William Steen.

1993

Conventional Forms: Insidious Visions. Glassell School of Art, The Museum of Fine Arts, Houston. Jan. 19–March 1.

Autoportraits Contemporains: Here's Looking at Me. Espace Lyonnais D'Art Contemporain, Lyon, France. Jan. 28–April 30. catalogue essay by Bernard Brunon.

Texas Art Celebration '93. 1600 Smith in Cullen Center, Houston. organized by the Assistance League of Houston. juror: David Ross. Feb. 16–May 1.

Personal Attachments: The Art of Collage. Hooks-Epstein Galleries, Houston. curated by Clint Willour. May 1–29.

Tin Cans and Bottle Caps. Fergus-Fernandes Gallery and R-M Gallery, Houston. June 11–July 3.

Houston in Hope. Faith and Charity in Hope Gallery, Hope, Idaho. Aug. 11. catalogue with introduction by Ed and Nancy Kienholz and statements by the artists.

Science Fair. Hallwalls, Buffalo. Jan. 16–Feb. 26 (a variation of this exhibition was presented at Southern Exposure, San Francisco, Sept. 3–Oct. 2).

Lawndale Live!: A Retrospective 1979-1990. Lawndale Art and Performance Center, Houston. Sept. 13–Oct. 16. catalogue essay by

Rachel Ranta and Elizabeth Ward.

LIGHT: Helen Altman, Joseph Havel, Douglas MacWithey, Ann Stautberg, John Wilcox. Barry Whistler Gallery, Dallas. Sept. 10–Oct. 9.

Texas Contemporary: Acquisitions of the '90s. The Museum of Fine Arts, Houston. Sept. 17–Nov. 21.

Sculpture on the Green. OMNI Hotel, Houston. curated by McKay Otto. Oct. 10–Nov. 30.

Blacks and Whites Together: A Conversation for Racial Harmony. Barnes Blackman Gallery and Midtown Arts Center, Houston. Oct. 22–Nov. 20.

TEXAS/Between Two Worlds. Contemporary Arts Museum, Houston. Nov. 19, 1993–Feb. 6, 1994 (traveled to Modern Art Museum of Fort Worth, Fort Worth, May 6–June 19, 1994; and Art Museum of South Texas, Corpus Christi, Sept. 16–Nov. 23, 1994). catalogue.

Small Wonders. Barry Whistler Gallery, Dallas. Dec. 3–24.

1994

Miniatures. Hooks-Epstein Galleries, Houston. Jan. 8–Feb. 8.

Speaking of Artists: Words and Works from Houston. The Museum of Fine Arts, Houston. Jan. 11–July 10.

The Light Fantastic. Laguna Gloria Art Museum, Austin. Jan. 22–March 13.

Texas Art Celebration '94. 1600 Smith in Cullen Center, Houston. organized by the Assistance League of Houston. juror: Ned Rifkin. Feb. 15–May 7.

The Crest Hardware Show. Crest Hardware Store, Williamsburg, New York. May 14–June 18.

Born Again Objects—Artists using found materials to reinvent ideas. Arlington Museum of Art, Arlington, Texas. May 19–Aug. 17. brochure.

Uncommon Objects. Barry Whistler Gallery, Dallas. June 17–July 30.

Born Again Objects. Bridge Center for Contemporary Art, El Paso. Sept. 9–Oct. 22.

The All Curley Show. Zero One Gallery, Los Angeles. Oct. 8–Nov. 12.

The Heights Exhibition. Lambert Hall, Houston. presented by the Houston Heights Association. Nov. 5–20. catalogue essay by Gus Kopriva.

Old Glory New Story: Flagging the 21st Century. Capp Street Project, San Francisco. Nov. 30–Feb. 4.

The Box. Hooks-Epstein Galleries, Houston. Dec. 2–31.

Small Works. Lynn Goode Gallery, Houston. Dec. 2– Jan. 7.

Drawings. Barry Whistler Gallery, Dallas. Dec. 2–Jan. 14.

1995

Gray Matters. International Gallery of Contemporary Art, Anchorage. Jan. 27–Feb. 26 (travels to Alaska State Museum, Juneau, March 17–April 22). catalogue.

* Originally known as the Lawndale Annex and part of the University of Houston's Department of Art, Lawndale Art and Performance Center has been an independent alternative space since 1989.

Selected Performances, Events and Videos

Titles followed by an "★" indicate program titles for an afternoon or evening of performance by the Art Guys which included the presentation of a group of works.

1983
The Art Guys Agree on Painting. Lawndale Art and Performance Center, University of Houston.

1984
Blue Sunday. City Hall, Houston.

The Art Guys At The Art Show. Hilton Hotel, Houston.

1985
Music for BB's and *Jumping Jack.* video broadcast on *The Territory*, KUHT-TV, PBS, Houston.

1986
LAB Works. Lawndale Art and Performance Center, University of Houston. Sept. 23–Oct. 2.

1987
OnWaugh Gala. Dan Allison's studio, Houston. June 20.

Music for Sideburns and *Artists Mud Wrestling* (with Paul Kittleson, David Kidd, Jackie Harris and Ed Wilson). Lawndale Art and Performance Center, University of Houston. Dec. 12.

Breakfast of Champions. Lawndale Benefit at the home of Frank Carroll, Houston.

1988
50 At Once. Commerce Street Warehouse, Houston. April 1.

Soul Patches for Kansas City. Kansas City Artists Coalition Gallery and University of Missouri, Kansas City, Missouri. April 9.

Dining At Denny's: Food for Thought. Denny's Restaurant, corner of Interstate 10 and Washington Avenue, Houston. Dec. 20–21.

Stunt Nite★ (with stunt man John "Red" Trower). The Orange Show, Houston. Oct. 8.

1989
Sipping Cokes: A three hour, thirty-three minute and thirty-three second stunt. San Jacinto College, Houston. Feb. 17.

Stunts and Skits.★ Memphis Center for Contemporary Art, Memphis. March 3.

Find the P.★ Brown Auditorium, The Museum of Fine Arts, Houston. March 21.

Spring Drop. Commerce Street Warehouse, Houston. April 1.

Any Damn Fool Thing.★ Museum of Southeast Texas, Beaumont, Texas. July 1.

Slap Happy. DiverseWorks, Art Against AIDS Benefit presented by The Houston Coalition for the Visual Arts, Houston. Sept. 17.

December Distribution Doubletake. Corner of Interstate 10 and Washington Avenue, Houston. Dec. 21.

Go Tee Off. Buffalo Bayou Park, Houston.

Chaos. Jesse H. Jones Public Library Plaza, presented by Diverse-Works, Houston.

1990
The Art Guys/The Reign/Sons of Dada. Downtown Grounds, organized by GVG Galleries with DiverseWorks and Downtown Grounds, Houston. June 27.

Come One, Come All Or Don't Come At All.★ The Heights Theater, Houston. June 29.

First Pitch (Houston Astros vs. New York Mets baseball game). The Astrodome, Houston. July 17.

Yard Crew. Contemporary Arts Museum, Houston. Oct. 3.

Driving Two Cars. Houston to Galveston, Texas. Nov. 9.

1991
101 Events. Gallery 3, Huntington, West Virginia. March 7.

Labor Day Weekend Roadside Sale. Interstate 45 at Holzwarth Road exit, Spring, Texas. Sept. 1–2.

1992
Ghosts at *SonicWorks.* DiverseWorks, Houston. Jan. 31.

Ask the Birds: An Evening With The Aaaaart Guise.★ Modern Art Museum of Fort Worth, Fort Worth. Feb. 5.

ZV Program. The Marsh, directed by Pamela Z. for *Life on the Water*, San Francisco. March 8–9. (The Art Guys presented videos *Music for BB's*, *Music of the Spheres* and *Jets*).

GAG Performance Rally. Protest Park, corner of Kirby Drive and Muirworth, Houston. Aug. 15.

An Evening in Flux. The Green Room, Brooklyn. Sept. 25.

DiverseWorks DiverseDonor Party at DiverseGuise Headquarters. Art Guys International Headquarters, Houston. Nov. 19.

Pamela Z and The Art Guys from Houston. The Marsh, San Francisco. Nov. 11.

The Aaaart Guise Paint New Orleans Red.★ Contemporary Arts Center, New Orleans. Dec. 5.

Keep A Dime Between Your Knees.★ Dallas Museum of Art, Dallas. Dec. 11.

1993
Video Salon de Roulette. 228 West Broadway, New York. March 11.

See The Funny Book In Front Of You. Brazos Bookstore, Houston. April 1.

Art Guys–Schmart Guys.★ Modern Art Museum of Fort Worth, Fort Worth. April 25.

Itty Bitty Witty Ditties.★ Marshall University, Huntington, West Virginia. Oct. 5.

Not Just Another Dog and Pony Show.★ Lawndale Art and Performance Center and the Fine Arts Department of Houston Community College, Central College, Heinen Theater, Houston. Oct. 15.

1994

*The Art Guys–Winging It, Singing It, Bringing It To You–Tried and True.** Herring Hall, Rice University, presented by the Contemporary Arts Museum, Houston. Jan. 22.

Getting It Together (a collaborative radio broadcast for the program *The Avant Garde*, KPFT 90.1 FM, in conjunction with *Rolywholyover: A Circus for Museum* by John Cage). The Menil Collection, Houston. Feb. 16.

A Tribute to Jerry Hunt: In Honor of John Cage. Rothko Chapel, presented by DiverseWorks in conjunction with *Rolywholyover: A Circus for Museum* by John Cage at The Menil Collection, Houston. Jan. 29.

*Lighten Up With The Art Guys.** Laguna Gloria Art Museum, Austin. Feb. 6.

*Art Guise Unplugged.** Modern Art Museum of Fort Worth, Fort Worth. April 19.

One Minute Axe. Zocalo Theater and Performance Company, Houston. July 23.

*Fish Out of Water.** Art Museum of South Texas, Corpus Christi. Oct. 6.

*Thirty Things in Thirty Minutes.** St. John's School, Houston. Nov. 3.

Exhibitions and Performances presented at the Art Guys World Headquarters

Since 1990, the Art Guys have presented their own work, as well as the work of other artists, at their home/studio, which is known by various names depending on the occasion, including: Art Guys World Headquarters, MOMAG (Museum of Modern Art Guise), Metropolitan Museum of Art Guys, Art Guise Ink, The Museum of Fine Art Guys, The New Museum of Contemporary Art Guise and The Museum of Fine Arte Guizados, Ink.

1990

Retro, Dude (Art Guys). opened June 16.

William Rhule (Jamaican folk artist). opened Aug. 25.

The Wellman Brothers Show Starring Gary and Steve. opened Dec. 8.

Year End Pre-Christmas Starving Artist Blockbuster Sale. Dec. 2.

1991

The Tim and Noah Show (Tim Glover and Noah Edmundson). opened Oct 26. music at opening by Stu Mulligan Project.

The Cartoon Show: Scott Gilbert, Rachel Hecker, David Kidd, Mike Pogue. Sept. 22–Oct. 19.

The Art Boys Are At It Again!!! Year End Pre-Christmas Sale! We've Made Too Much . . . ! Dec. 7–8.

1992

Sound Sculptures. Benefit Auction and Party for Sonic Works, a program of DiverseWorks. Jan. 11.

3 In a Row/1 of 3 Circumstances: Giles Lyon. April 11–22. music at the opening by Kingfisher.

3 In a Row/2 of 3 Laurent Boccara, Sharon Engelstein, Susie Rosmarin, Aaron Parazette. April 25–May 6. entertainment at opening by Turtle Doves, Need to Pee, Mucous.

3 In a Row/3 of 3 Fax of Life. May 9–20. entertainment at the opening by Stu Mulligan Project.

Introductions '92: Two Guys' Art. opened July 11.

Hearts and Minds: New Works by Mike Barry. opened Oct. 10.

The Explanation of everything according to the doctrine of Orthodox Paganism. Aart Guys Ink. along with The First Church of the Exquisite Panic, Inc., Robert Delford Brown, Founder, Leader and President. Dec. 19–Jan. 5.

1993

The Hunt Oil Works by Donald Lipski. opened April 22.

Summer Close Out Blockbuster Sale!!! June 19 –20.

That's Painting Productions. Sept. 4–30. Bernard Brunon painted the entire house and studio.

Richard Turner: The Fifties Become the Sixties. opened Sept. 18. opening performance by Terry Andrews, *The Game.*

1994

DiverseWorks presents Farm Girls at the Museum of Modern Art Guys. Feb. 11–12.

Annabel Livermore. Oct. 29–Nov. 20.

Year End Sale. Dec. 10–11.

figs. 29–30 Sketchbook pages, 1992 & 1994, graphite on paper. Collection the artists.

Selected Bibliography

Blank, Harrod. "The Art Guys." *Beer: The Magazine* (November 1994): 2.

Bott, Harvey. "X-Press Yourselves: An Interview with the Art Guys." *ARTlies* (May/June 1994): 12–13.

Brunon, Bernard. *Autoportraits Contemporains: Here's Looking at Me* (Lyon: Elac Art Contemporain, 1993).

Chadwick, Susan. "The Art Dudes a la carte: 24 hours at Table 20." *The Houston Post*, December 22, 1988, C1, C12.

_____. "Art Dudes get the scoop on selling papers." *The Houston Post*, December 25, 1989, D3.

_____. "Art Guys get serious—really, no kidding." *The Houston Post*, July 20, 1992, D1, D8.

_____. "Museum lawn gets a 'Yard Crew' cut." *The Houston Post*, October 3, 1990, D2.

_____. "Performance Guys are really pranksters at art." *The Houston Post*, June 25, 1990, D1, D4.

_____. "Shows introduce works of Michigan and Mexico." *The Houston Post*, December 25, 1987, 4D.

Cunningham, Kevin. "Vetoed Vision." *Houston Press*, March 22, 1990, 12–13.

Fisher, Saul. "Bona Fide Concerns." *Public News*, September 28, 1988, 13.

_____. "Devise and Concert." *Public News*, October 21, 1987, 11.

Gambrell, Jamey. "Art Capital of the Third Coast." *Art in America* (April 1987): 186–203.

Goddard, Dan. "'Dialogues:' Urban blithe." *Express News*, February 10, 1991, 1H, 5H.

_____. "Macabre: Fangs for the Memory." *Express News*, November 8, 1987, 7H.

Holmes, Ann. "Interchange with art: Road to winning highway design contest is paved with creativity." *Houston Chronicle*, March 25, 1989, 3D.

Johnson, Patricia. *Contemporary Art in Texas* (Roseville East, New South Wales: Craftsman House, 1995), 20–23.

_____. "Experience Installations." *Houston Chronicle*, December 7, 1985, 6:6.

_____. "The Range of Sculpture.'" *Houston Chronicle*, May 31, 1987.

_____. "Who art these guys? Pair's tongue-in-cheek art has serious message." *Houston Chronicle*, June 15, 1990, 1F, 4F.

Kalil, Susie. "Wink, wink." *Houston Press*, March 24–30, 1994, 30.

Kandel, Susan. "Meet The Art Guys: Jack Massing and Michael Galbreth." *Los Angeles Times,* November 12, 1992, F6.

Kopriva, Gus, and Marti Mayo. *The Heights Exhibition* (Houston: Houston Heights Association, 1994).

Kutner, Janet. "'Texas Dialogues:' On the cutting edge of art." *Dallas Morning News*, July 6, 1991, 1C, 5C.

Landay, Janet. *Collaborators: Artists Working Together in Houston 1969–1986* (Houston: Glassell School of Art, The Museum of Fine Arts, Houston, 1986).

Lewinson, David. "2 Exhibits Give Impressions of the World Around Artists." *Los Angeles Times*, May 12, 1989, 6:1.

Locke, Charmaine, and James Surls. *Sculpture: The Spectrum* (Houston: Lawndale Art and Performance Center, University of Houston, 1987).

Ludlum, Jane. "2 Yard Crew: Visible as they wanna be? Not local artists, not in the CAM." *Houston Press*, October 11, 1990, 32.

McBride, Elizabeth. "Art Guys' Playful Works." *Public News*, February 1, 1989, 12.

_____. "Introductions 1992 and Houston's Artists: Aaron Parazette and the Art Guys." *Public News*, September 2, 1992, 14.

McBride, Elizabeth, and Lorenzo Thomas. *DiverseWorks Artspace: 1983–93* (Houston: DiverseWorks Artspace, Inc., 1993).

Paris, Wendy. "Review." *Sculpture* (November–December 1991): 58.

Patoski, Joe Nick. "Art Guile." *Texas Monthly* (May 1991): 70, 86.

Perachio, Elise. "The Art Guise 'Driving Two Cars to Galveston.'" *The Strand Sentinel* (Galveston), November 8, 1990, 8.

Ranta, Rachel, and Elizabeth Ward. *Lawndale Live! A Retrospective 1979–1990* (Houston: Lawndale Art and Performance Center, 1993), 20–21, 40–41.

Rashish, A.B. "Stump the Art Audience." *Public News*, September 25, 1986, 13.

Rust, Carol. "Urban recycling: Artists rescue castoff items for furnishings." *Houston Chronicle*, May 28, 1991, 1D, 10D.

Smith, Michael. "Art Guys bring their works to where the people are." *The Houston Post*, September 3, 1991, A13.

Steen, William. *Avenues of Departure: Twelve Houston Artists* (New Orleans: Contemporary Arts Center, 1992), 8–11.

Waddington, Chris. "Highs and lows from Houston." *New Orleans Picayune,* January 1, 1993, L10.

Ward, Charles. "What's the sound of plastic unrolling? Irreverant explorations give edge to new music festival." *Houston Chronicle,* February 4, 1992, D1.

fig. 31 **Screwball** from **The Eyes Have It**, 1991,
baseball, googly eyes and glue